Y0-EKR-364

IMAGES
of America

ANSONIA

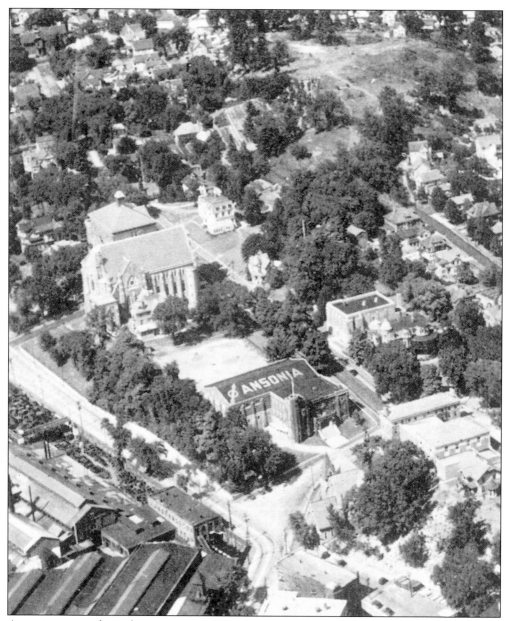

Ansonia is seen from the air, prior to World War II. The building with "Ansonia" painted atop it and the compass pointing north is the Ansonia Armory at 5 State Street. The Masonic Temple, built in 1925, is across North Cliff Street. Just below the temple is the domed roof of the Franklin Farrel mansion. To the upper left of the armory is Church of the Assumption, with its school next to it. To the right, just below the armory on State Street, is the YMCA, built in 1924. Farrel-Birmingham is the large factory complex on the lower left of the picture. The Methodist Church is across Main Street from Farrels near the bottom of the picture. Eagle Hose Hook & Ladder Company No. 6 has its firehouse right on top of the old canal at the intersection of State, Main, and North Main Streets. A portion of the canal can be seen behind it, at the lower right of the picture, where East Main Street is today. At the foot of the hill, between the armory and firehouse, is the First Baptist Church.

IMAGES
of America

ANSONIA

The Derby Historical Society

Book Committee Chairman: Robert J. Novak Jr.
Co-Chairs: David Carver
Markanthony Izzo
Jeanette LaMacchia

ARCADIA
PUBLISHING

Copyright © 1999 by The Derby Historical Society
ISBN 978-0-7385-0252-6

Published by Arcadia Publishing
Charleston, South Carolina

Printed in the United States of America

Library of Congress Catalog Card Number: 2008922378

For all general information contact Arcadia Publishing at:
Telephone 843-853-2070
Fax 843-853-0044
E-mail sales@arcadiapublishing.com
For customer service and orders:
Toll-Free 1-888-313-2665

Visit us on the Internet at www.arcadiapublishing.com

CONTENTS

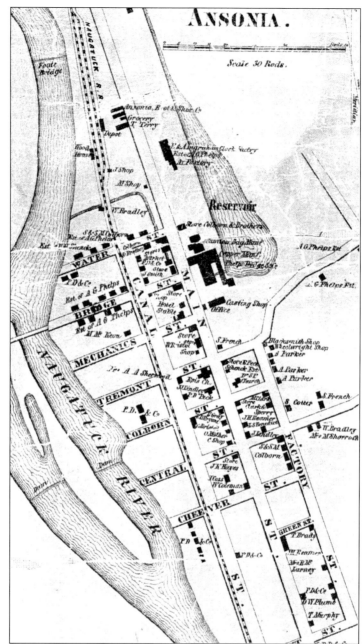

A map of pioneer town Ansonia appears in its infancy in 1856. Many of the buildings are labeled "Est. (Estate) of Anson Phelps," as Ansonia's founder had died three years before. The dotted line represents the Naugatuck Railroad. Main Street is already beginning to be lined with small businesses. There is no Maple Street Bridge at this time, and the small, unlabeled buildings at the top are Farrel Foundry. There are only two other major employers at this time. One major employer was the Ansonia Clock Company (which at this time also temporarily housed the Ingraham Clock Company, while they rebuilt their burned out factory in Bristol) in the large rectangular building near the millpond. The largest building, in the center, housed Phelps and Dodge Company, which was a copper mill.

INTRODUCTION

It is with great pride that I write the foreword for *Ansonia*, the second *Images of America* Series book produced by the Derby Historical Society, in August of 1999.

Mindful of the approaching end of the millennium, we had been considering producing an *Images of America* series book for some time. One would think the most obvious topic would be Derby, since we derive our name from that community. But anyone familiar with the Historical Society would know it is not that simple. Our headquarters, the General David Humphreys House, once an integral part of Derby, now lies in Ansonia, as does the Reverend Richard Mansfield House on Jewett Street, which we also maintain. As we are a regional organization, many of our members, including our current president, Jeremiah Vartelas, are either present or former Ansonia residents. It would be impossible to do a book without touching upon the common roots that both communities share.

Thus, the decision was made to produce separate books simultaneously on Derby and Ansonia. This resulted in a thoroughly intense, exhausting, though infinitely rewarding experience during the summer of 1999. Over 700 vintage photographs from a variety of sources were reviewed for the books, 212 of which appear in *Ansonia*.

Many facets of Ansonia's history that I was not aware of came to light as this book was researched. Residents of the City of Ansonia have every right to be proud of their community's heritage, and will hopefully share the thrill of rediscovering almost forgotten community roots. Much of the groundwork, up to 1976, had already been laid by our former late Executive Director Dorothy Larson. Mrs. Larson chaired the committee that produced the superb "A *History of Ansonia*" that year, which I highly recommend to anybody wishing for more information on Ansonia's wonderful past. This book takes an entirely different approach, telling the story mostly in pictures, rather than text.

The approach has its pros and cons. On one hand, priceless images are contained here that, as the old cliché saying goes, would take a thousand words to describe. However, in a town like Ansonia which once boasted 25 churches alone, it is inevitable that some things will be left out. We would have liked to include them, but due to the lack of available photographs, it was something over which we had little control.

The scope of this book is the area of the Naugatuck Valley now occupied by the City of Ansonia. Some of the history, particularly in the first chapter, is shared with the neighboring town of Derby, of which Ansonia was a part until 1889. The book continues through Ansonia's history, various periods being broken into chapters, until 1955. Special chapters on Farrels and

Ansonia's wonderful old homes are presented, as well as chapters on the Blizzard of 1888, and the Flood of 1955, two calamities that were extensively photographed. The last chapter covers some of the highlights of Ansonia's history from the redevelopment days after the flood until the mid-1970s.

All photographs, unless otherwise noted, come from the extensive photograph collection amassed for the last 50 years by the Derby Historical Society. I would like at this time to thank Ansonia Mayor Nancy Valentine, who answered the Historical Society's call for additional historical photographs almost immediately, notifying the Ansonia Library and allowing us the use of their historic photograph collection as well. Besides the Historical Society, the Library has the largest number of photographs appearing in this book. Ansonia Library Executive Director Joyce Ceccarelli and Library Historian Phyllis Judd also deserve thanks for assisting us. Other sources of photographs include the Ansonia Police Department, Fountain Hose Co. No. 1, Charters Hose Co. No. 4, and Hilltop Hose Co. No. 5. David Carver, who has preserved and duplicated many old Ansonia photographs, and Marian O'Keefe, who had the foresight to photograph and catalog vintage Naugatuck Valley homes years ago, also deserve thanks.

Photographs belonging to the Historical Society used in this book included those taken or donated by the following over the years: Treskunoff Studio of Ansonia, Farrel-Birmingham Company, Sturgis Sobin, Anne Bryant Bassett, the New Haven Colony Historical Society, Clara Barton Drew, Ansonia Municipal Historian Dr. Margaret Gibbs, George Alton Brown, George Bush Clark, Lawrence Larson, Franklin Farrel III, Publishers' Photo Service Inc., L.G. Enderlin, Myles P. Fillingham, and the U.S. Marine Corps.

Finally, at the risk of leaving someone out, I would like to thank the following people who assisted in producing this book. Ansonia resident David Carver worked countless hours with me on nearly every stage of production. Also of immense help were former Historical Society president Jeanette LaMacchia and Markanthony Izzo. Dr. Margaret Gibbs, Jeremiah Vartelas, John Brady, Rita Breese, Ansonia Police Chief James McGrath, Second Lieutenant Ron Burgess of Fountain Hose, "Webmaster" Joseph Navin of Charters Hose, and Captain John Pellicani of Hilltop Hose also provided information or assistance used in the making of this book. The Society's administrative assistant Lorraine Axon also deserves thanks for "holding down the fort" while we were focused on the books, as well as the Derby Historical Society's Executive Board for granting their approval. Lastly I would like to thank my wife Michelle and my children for understanding the importance of producing a visual history of Ansonia (and Derby) and being supportive despite protracted absences from home and nearly every free minute being devoted to the books' production.

In 1880, Samuel Orcutt wrote in his local history, "History is a record of experiences in the ages that are past; and experience, while varying through the changing of circumstances, is a teacher worthy to be carefully studied, and to whose voice it is wise to listen." Through the photographs in this book, readers can have the satisfaction of reaching out to those who came before, the enriching opportunity of sharing the same sights, scenes, landscapes, and experiences as those alive in the time periods depicted. It is our hope that the reader will finish this book and feel the same pride and admiration for the City of Ansonia and its history as we do.

Robert Novak Jr.
The General David Humphreys House
Ansonia, Connecticut

One

ANSONIA'S ROOTS

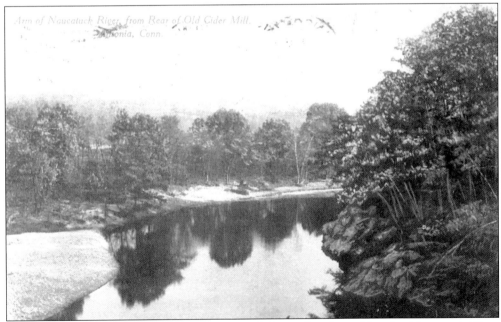

Anson Phelps's engineer John Clouse surveyed the valley formed by the Naugatuck River upstream from the manufacturing village of Birmingham in 1844. From a ledge near present-day South Cliff Street, he exclaimed it was "one of the finest places for a village in the Western World." This picture shows the Naugatuck River in the condition Clouse probably found it, where Ansonia would be built. (Ansonia Library.)

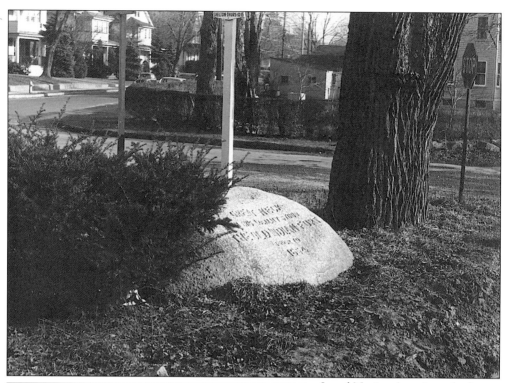

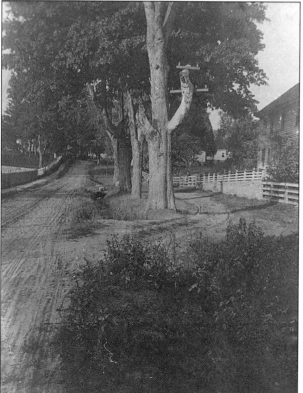

Local Native Americans had almost disappeared by the time Clouse surveyed the lands of the future Ansonia. Long before his arrival, though, the Paugussetts of the Algonquian tribe occupied the land. Their chief seat and fort was located at Great Neck, on what was later called Bare Plains. This stone on the corner of Wakelee Avenue and Division Street marks the site of the fort in 1654.

A 19th-century view shows Elm Street, part of old Derby's "Uptown." Known as Old Town Road in the late 17th and 18th centuries, the name was changed to Elm Street due to the stately elms that grew on both sides of the street, forming a canopy over the road. Elm Street was established as an historic district in 1969.

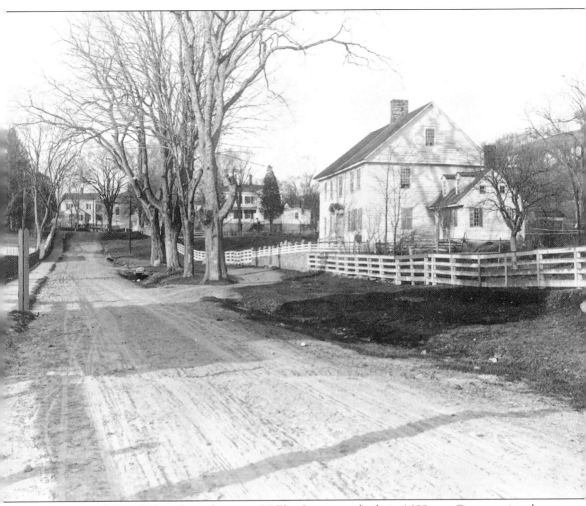

The General David Humphreys house at 37 Elm Street was built in 1698 as a Congregational parsonage for Reverend John James, who was also town clerk and first schoolmaster. After a few years, he was forced to resign for health reasons, selling the house to Reverend Joseph Moss. Moss served the parish for a number of years until his death on January 23, 1731. The house was enlarged and rebuilt in 1733. After Moss's death, Reverend Daniel Humphreys became the third minister to reside there. Reverend Humphreys married Sarah Riggs in 1739, who was called "Lady Humphreys" for her aristocratic bearing and demeanor, as well as her great beauty and intelligence. Their son, the famous General David Humphreys, was born here. After 1800, the old Episcopal Church was moved across the street and attached to the house. For many years, the house was in possession of the Humphreys House Association, organized by several public-minded persons interested in preserving the old house, which had been converted into a three-family apartment. The house was turned over to the Derby Historical Society in 1961, who voted to restore the house on June 4, 1964.

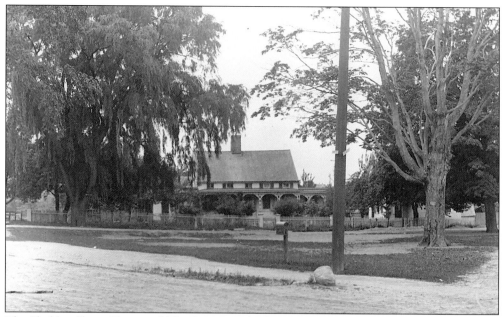

The Sheldon Curtis House at 3 Elm Street was built around 1789. In the early 1800s, this house served as a traveler's inn. The stagecoach between Humphreysville (Seymour) and New Haven passed here, and this house served as a water stop and place to change horseshoes. A porch was added during the Victorian era. Elm Street School later put a World War I monument on the small green in front.

The Captain Joseph Riggs house was built at 13 Elm Street in 1760. Captain Riggs was prominent in Derby town affairs in his time. He managed the first lottery held in this area, in 1782, which raised funds to build two bridges across the Naugatuck River, and a highway from Derby to Woodbury. The school sign is for nearby Elm Street School. (Marian O'Keefe.)

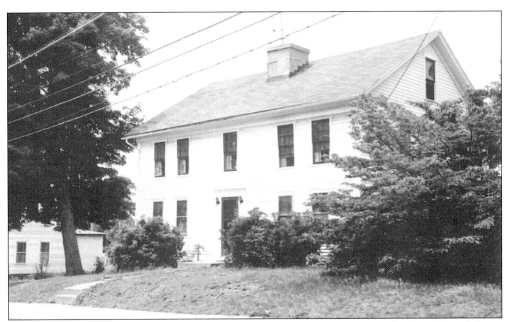

This house at 54 Elm Street was built in 1712. John Holbrook and his wife Abigail lived there. They donated the land for the Episcopal Church and graveyard. The house was later called the Blakeslee House, because in 1792 Rev. Edward Blakeslee, an Episcopal priest, son-in-law and assistant to Reverend Mansfield, bought the house. He died there in 1797. (Marian O'Keefe.)

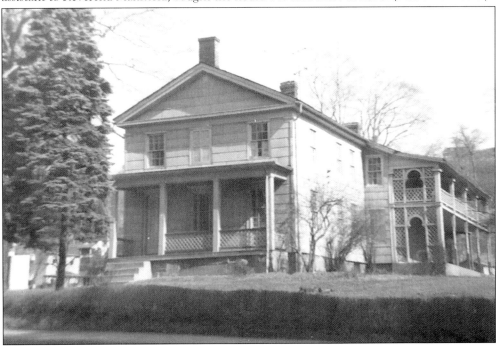

A two-room house was built at 65 Elm Street in 1778. It was reconstructed in 1830. Anson Phelps's daughter Caroline and son-in-law James Stokes owned the house in the 1850s, and used it as a summer home. Anson Phelps spent much time here. Caroline and James's daughter, Caroline Phelps Stokes, donated Ansonia's library to the city. (Marian O'Keefe.)

13

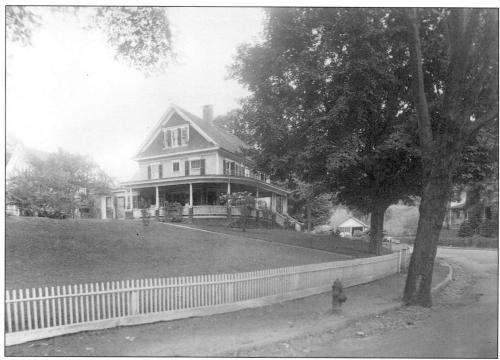

This house on 74 Elm Street was built in 1798 by Josiah Smith. Several generations of the Smith family lived here before selling to Jonah Platt. The house was built in the Georgian style, but a Victorian-style porch was later added. The house is located on the corner of Elm and Main Streets.

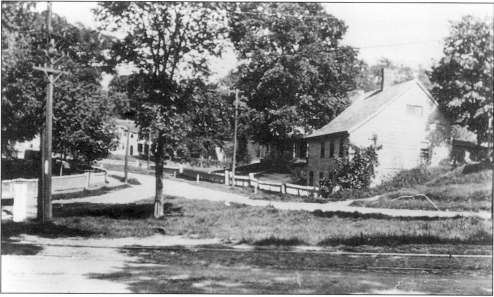

An 1895 view is of the corner of Main and Elm Streets. The house on the right was built in 1793 by Claudius Bartleme (1737–1824), a Huguenot sea captain who was born in France and immigrated to the area via Canada in 1762. He was renown for firing upon the Stratford toll bridge when the attendant refused to draw it until he saw Bartleme's papers.

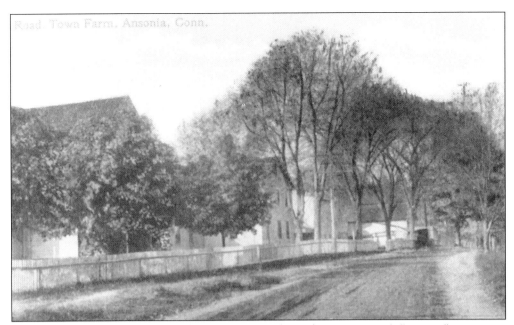

Road. Town Farm, Ansonia, Conn.

The Town Farm, also known as the Poor House where the community's "paupers" were sent, was located near where Nolan Field is today on Wakelee Avenue. The foundation of one of the houses is still visible from the exit ramp of Route 8's Exit 19. The remaining buildings were torn down in the 1960s.

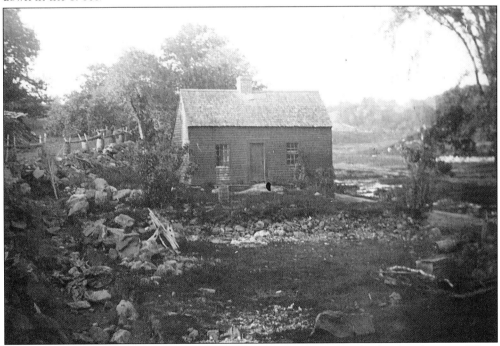

This small, saltbox-style house stood on land that was later bought by the Ansonia Water Company. The location was "along the old highway" on Beaver Street, now under the water of the reservoir. The Water Company was organized in 1868, and by the time this photograph was taken, the house had been abandoned for the reservoir project.

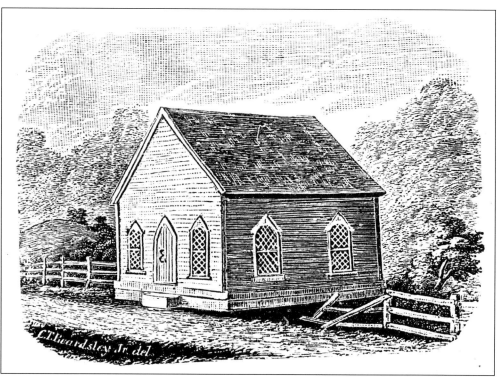

The future Ansonia was home to the Valley's first Episcopal church. This modest church was built on a piece of land in the southeast corner of the Episcopal Burying Ground on Elm Street in 1737. The land was given by Captain John Holbrook, who lived adjacent to the cemetery. This church was built by the initial eight families it served. The church was replaced by a larger one on Derby Avenue around 1790.

The Episcopal Cemetery sprung up around the old church. Although the church has long gone, many generations of Ansonia and Derby Episcopal families continued to bury their dead here. The pillar with the cross atop it is the grave of Reverend Richard Mansfield, and marks the location where the old church's alter once was. The General Humphreys house, before it was restored, is across the street. (Marian O'Keefe.)

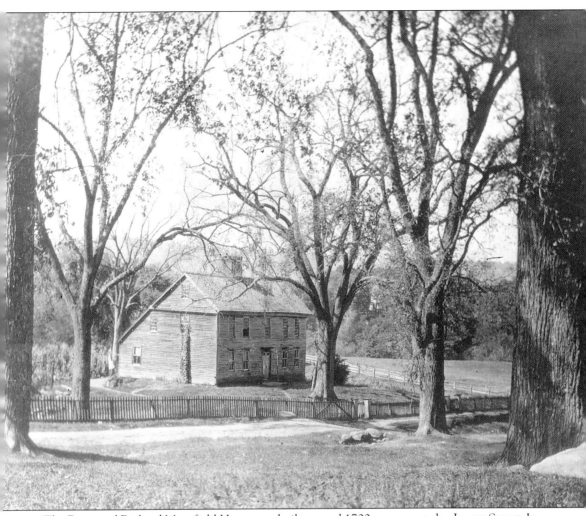

The Reverend Richard Mansfield House was built around 1700 on present-day Jewett Street. In 1747, the new Episcopal Church purchased the house for its first rector, Reverend Dr. Richard Mansfield, and it became a "glebe house." Even after his death, the house continued to be called "the Mansfield Place." In 1925, a group of Polish Roman Catholics purchased the property. St. Joseph's Polish Roman Catholic Church and School were built on the spot formerly occupied by the Mansfield House. To make room for the new parish's buildings, the historic structure was moved across the street to its present location in 1926. The Mansfield House Association was formed to preserve the house at that time. The Association later gave the house to the Antiquarian Landmarks Association. They in turn gave the house to the Derby Historical Society in 1960, who continue to maintain it. This picture of the Mansfield house was taken in the 1860s. Reverend Mansfield planted the elms surrounding the house. (David Carver.)

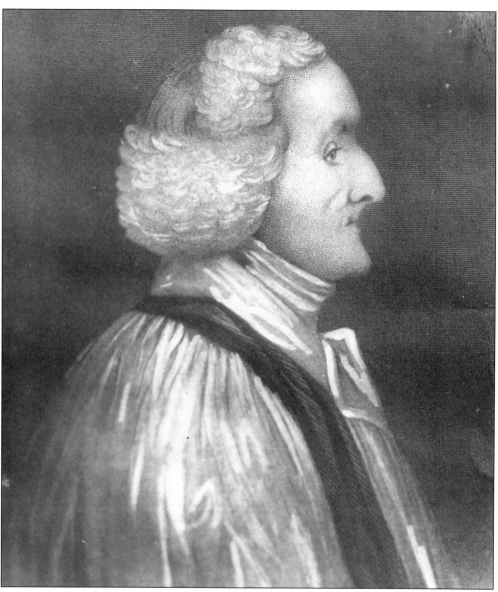

Reverend Richard Mansfield was born in New Haven in October 1724. He graduated with top honors from Yale in 1741. Shortly after college, he broke from the Congregationalist faith and decided to become an Episcopalian minister. Legend has it that his family was so upset by the scandal, they prayed that his ship might sink when he went to Canterbury, England, for his ordination. Returning to America in 1748, he was assigned the new Elm Street parish; which by then embraced all territory between New Haven and Waterbury. He ministered his scattered flock on horseback until 1775, when Derby, Ansonia, Oxford, and Seymour became his only charges. A loyalist to the crown during the Revolutionary War, he was forced to flee his Elm Street pulpit when American soldiers arrived to arrest him. He fled to Long Island. After nearby towns were burned by the British, many "loyalists" found themselves embracing the colonial cause, and Reverend Mansfield was allowed to return and preach (as long as a guard was present) as a way of healing the community's wounds. Mansfield served his parish until his death in 1820, an amazing 72 years!

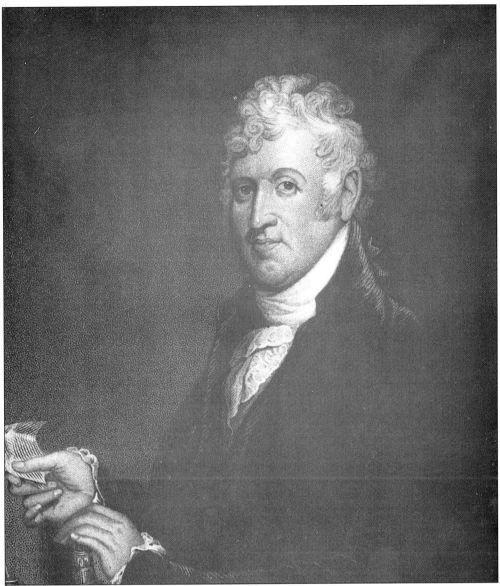

General David Humphreys was born in the Humphreys House on July 10, 1752, fourth son to Reverend Daniel and his wife Sarah Riggs Humphreys. He attended Yale College at the age of 15, where he became known for his poetry. (He and two others were dubbed "the young bards of Yale.") He graduated with distinguished honors in 1771. He returned to New Haven, intending to become a teacher, when the Revolutionary War began, and quickly enlisted in the Continental Army. He became General Putnam's aide-de-camp, with the rank of Captain. In 1780, he became aide-de-camp to General George Washington. A friendship quickly developed between the two. He accompanied Washington in a number of campaigns. During the decisive Battle of Yorktown, Humphreys ably led a separate command. After the battle, British General Lord Cornwallis surrendered and tried to give his colors to French General Lafayette, in an attempt to humiliate his old nemesis Washington. Lafayette turned the tables by ordering Cornwallis to surrender to the American general. Upon receiving Cornwallis's flag, Washington entrusted it to Humphreys.

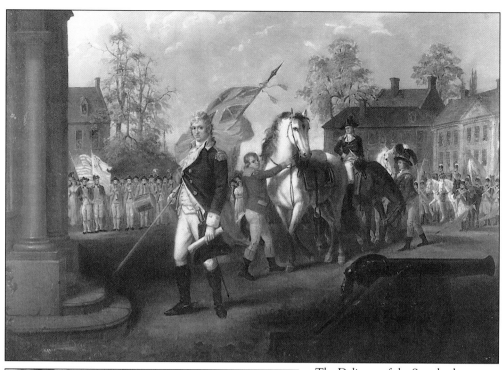

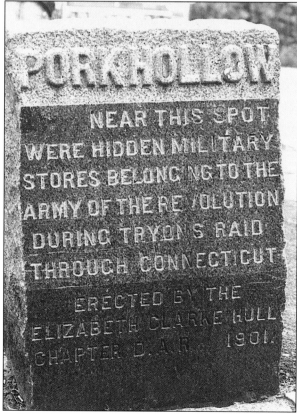

The Delivery of the Standards (1840) depicts Humphreys arriving in Philadelphia in 1781 with Cornwallis's flag to announce the end of the Revolutionary War. Humphreys continued his close relationship with Washington after the war, living at Mount Vernon for a while. He was appointed our nation's first ambassador to a foreign country, Portugal, in 1789. He later became the ambassador to Spain.

Upon learning the British planned on raiding a Derby warehouse loaded with pork, Joseph Tomlinson rode 20 miles from New Haven to sound the warning. Under the cover of darkness, the pork was transported to a spot under some scrub oaks on today's Wakelee Avenue, forever after known as "Pork Hollow." The raiders returned empty handed. This monument was erected by the Daughters of the American Revolution (DAR) in 1901.

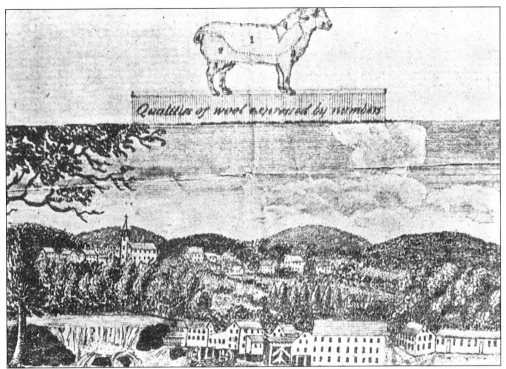

While in Spain, Humphreys was given Merino sheep, which gave wool in higher quality and quantity. He returned to Derby in 1802 with almost 100 of these sheep. Giving matching pairs to the local farmers in exchange for a percentage of the wool, he founded the village of Humphreysville (presently Seymour), which centered around manufacturing wool textiles. He died on February 21, 1818, and is buried in New Haven.

Moulthrop Street is named after the Moulthrop family who owned a farm on the street near Beaver Street. The Moulthrop house was built in 1835 upon the site of the first house built in the Beaver Brook, sold by the Native Americans to Jabez Harger and John Hulls in 1668. The old Ansonia High School can be seen behind the tree.

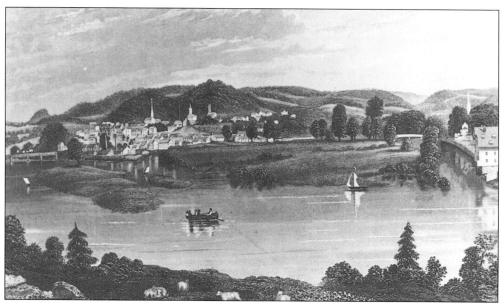

In the 1830s, Sheldon Smith and Anson Phelps founded the manufacturing village of Birmingham between the Housatonic and Naugatuck Rivers. Tapping the power of the Naugatuck River with a canal, Derby's newest section grew at a phenomenal rate. By the mid-1840s, Anson Phelps was considering expanding the village. This painting was done in 1849.

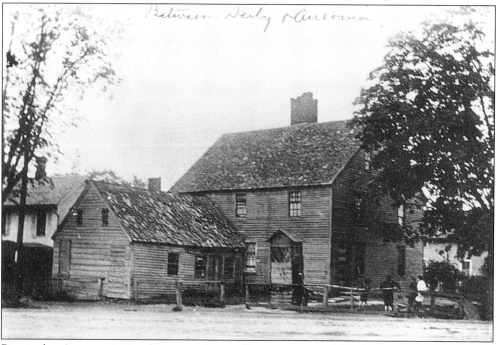

Birmingham's expansionist plans were thwarted by a man named Stephen "Squire" Booth, who purchased the "Old Bassett Farm" (pictured here), which included key property needed for the expansion along Division Street, and Atwater and Clifton Avenues. The shrewd Booth continued raising the price of the farm until an exasperated Phelps gave up on the idea of expansion and began surveying the Naugatuck River for a second manufacturing village site.

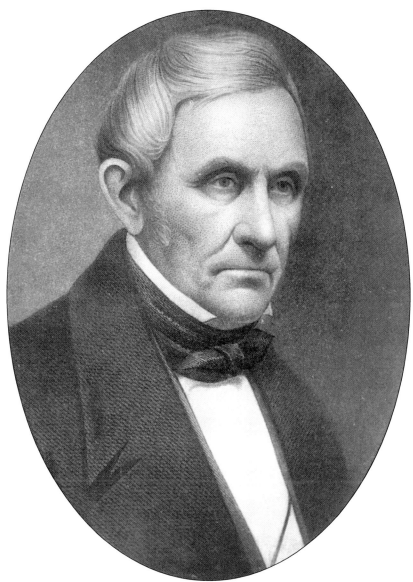

Anson Green Phelps was born in 1781 in Simsbury, Connecticut. Orphaned by age 11, he was raised by a minister. He established a business at an early age in Charleston, South Carolina, before relocating to New York City. After accumulating a fortune, he became interested in starting new enterprises and villages. He played a prominent role in the formation of Derby's Birmingham, becoming the chief pillar in the new community after the departure of Sheldon Smith. When his plans for expansion to the north were thwarted, he established a second manufacturing village upstream, on the east bank of the Naugatuck River. The idea of naming the new village "Phelpsville" was abandoned when it was learned that another community with that name existed. At the advice of Derby physician Ambrose Beardsley, the village was named "Ansonia," a latinized version of his first name. Anson Phelps was a model Christian, Samuel Oructt writing about him, ". . . unlike most men in large business enterprises, he carried his religion into almost every line and department of work, and to this principle, he attributed his success." Anson Phelps died in New York in 1853.

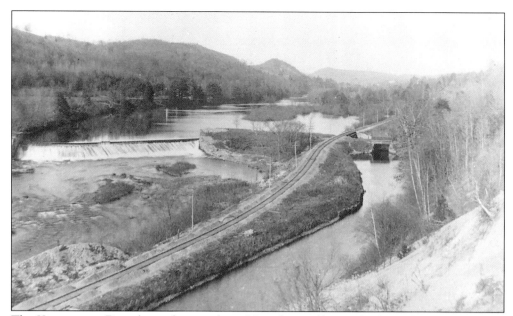

The Kinneytown Dam, located in southern Humphreysville, was built in the early 1840s by Raymond French. Anson Phelps purchased the dam from French in late 1844. Humphreysville broke from Derby in 1850, changing its name to Seymour. The dam, canal, and railroad are shown here. The millpond below the Kinneytown Dam is a familiar sight to motorists along the Route 8 highway just above the Seymour town line today.

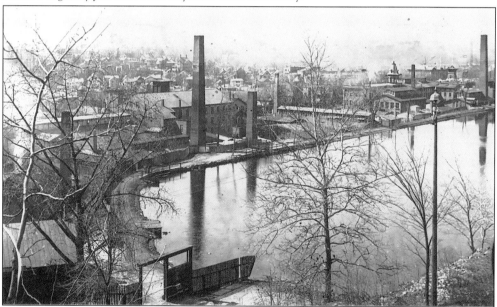

Construction of a canal along the east bank of the Naugatuck from the Kinneytown Dam to provide waterpower to the new village began in 1845, and it was completed a year later. Water returning to the Naugatuck River through underground sluiceways powered massive waterwheels and turbines, which in turn generated power. The canal, which once cut through the heart of downtown Ansonia, has been filled in today. This photo shows the canal and the mills that developed around it from the Tremont Street hillside around 1895.

Two

EARLY DEVELOPMENT

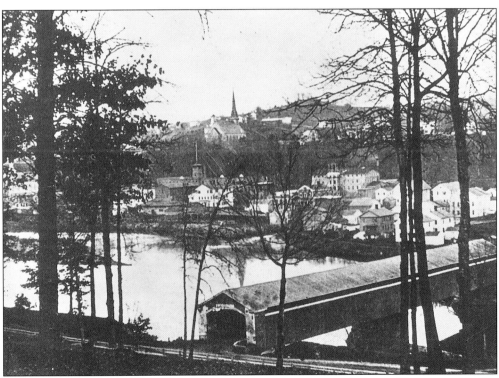

This 1868 view of Ansonia is from the west side of the Naugatuck River. The covered bridge crosses on what is now Bridge Street. Early houses, stores, and mills line Main Street. The recently completed stone Congregational Church is on South Cliff Street upon the hill. The large building to the right under the church is the Clock Company, the one directly under the church with the tower is Osborne & Cheeseman manufacturers.

Almon Farrel (1800–1857) was born in Waterbury, the son of a millwright. In 1844, he became Anson Phelps's master mechanic and millwright. He played a large role in the construction of the canal, as well as building Anson Phelps's copper mill. In 1847, he acquired a tract of land along the canal, and started a small foundry and machine shop called Almon Farrel & Company. The name changed several times. Shortly after his death, it became Farrel Foundry & Machine Co.

Early products of Farrel Foundry & Machine Co. were brass and iron casting, power drives, and gears for water-powered mills, metal rolling mills, and sugar mills in the West Indies. The foundry was powered by water from the Ansonia canal. Much of the business of the Foundry centered on providing machinery to the rapidly expanding mills up and down the Naugatuck River. This picture was taken around the time of the Civil War.

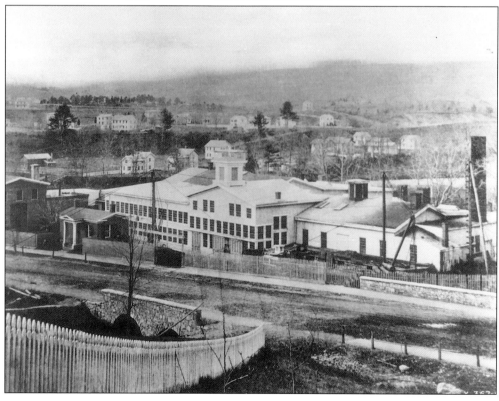

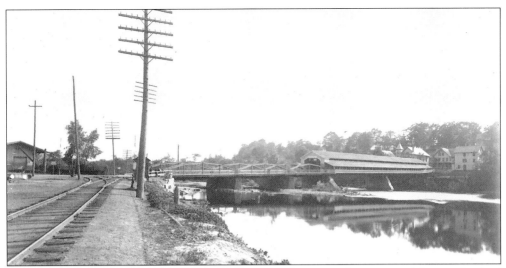

The covered Bridge Street bridge spans the Naugatuck in a southern view of the east bank of the Naugatuck River, where this picture was taken. The freight depot is on the left. No less significant than the canal was the completion of the railroad in 1849. The railroad ran from Bridgeport to Winsted, with Ansonia being one of its stops.

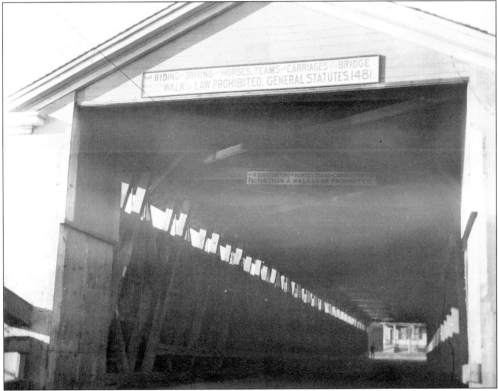

This is a look inside the old covered bridge on Bridge Street. The sign reads "The riding or driving of horses, teams, or carriages on this bridge faster than a walk is by law prohibited." Besides sheltering human passengers from the elements, covered bridges were supposed to prevent horses from panicking and leaping over the edge into the water.

27

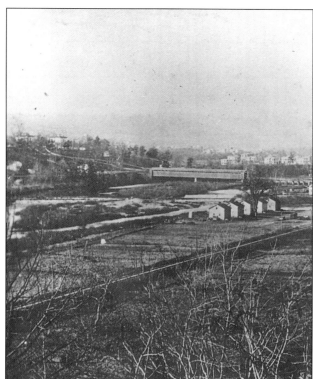

This photograph is perhaps the earliest image ever taken of Ansonia. The view is to the northwest. Houses line Main Street both north and south of the Bridge Street bridge, which was covered from end to end back then. The line between the houses and the trees in the foreground is the railroad tracks. Very few streets are laid out.

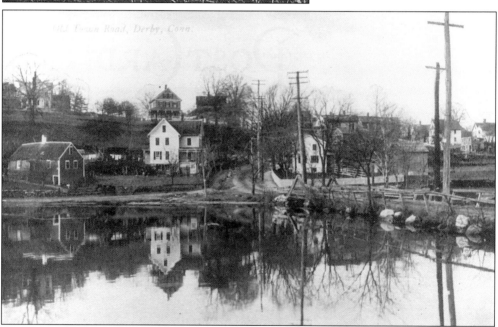

The future border between Ansonia and Derby would run in the middle of what was then called Old Town Road, but is now known as Division Street. The house on the left was torn down in 1998 to make room for street widening. Atwater and Clifton Avenues are at the top of the hill. The water in the foreground is the Birmingham Canal, which has since been filled-in. Pershing Drive passes here today.

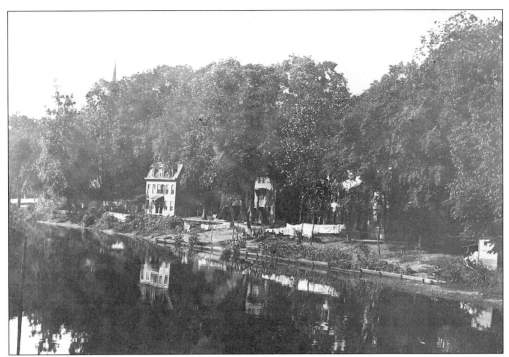

Factory workers were housed in tenements clustered in a community called "Undercliff," along the canal bank. The spire of the Ansonia Baptist Church rises in the background. This photograph was taken from the pedestrian footbridge over the canal. East Main Street now runs along the route of the old the canal.

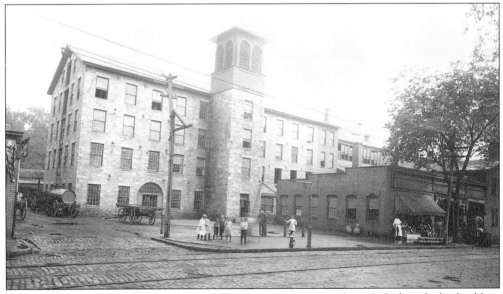

Anson Phelps's copper wire mill on Main Street was incorporated in 1845, though this building came a bit later. It merged with Birmingham Copper Mills after it burned in 1854, and became Ansonia Brass & Copper Company in 1869. Wire, brass, kettles, copper tubing, and beds were manufactured there. This picture was taken after 1888. The store with the awning to the right is David Haddad's vegetable market, while next door is undertaker Jeremiah Flahaver.

English-born immigrant Thomas Wallace (1797–1875) came to America at the invitation of Birmingham's Dr. John Howe to work in his pin factory. Mr. Wallace later established the brass industry in Ansonia when he founded Wallace & Sons brass foundry in today's North End in 1848. It was located on the southern tip of North Liberty Street. This photo shows the carbon shop. His son was an electrical pioneer.

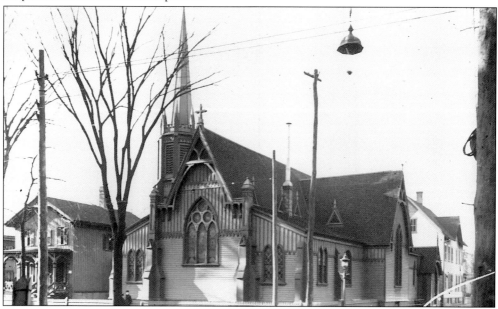

After the removal of the Episcopal Church of St. James from Derby Avenue to Birmingham in 1843, a small but loyal band of East Derby and Ansonia Episcopalians continued to worship in the old church. In 1849, they formally organized Trinity Episcopal Church of Ansonia, soon to be renamed Christ Church. The first church and parsonage, pictured here, were located on Main and Tremont Streets.

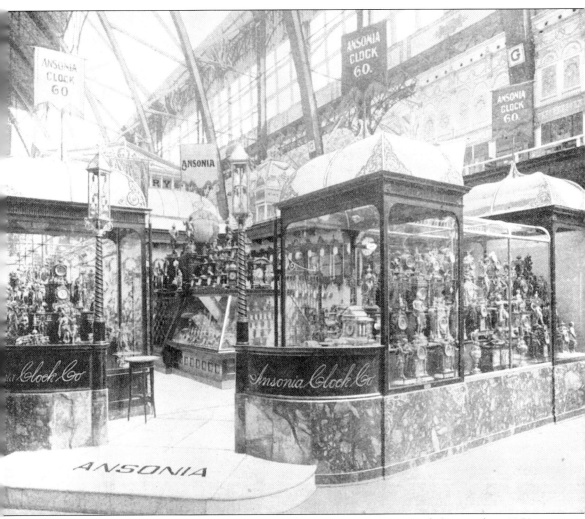

The Ansonia Clock Company was established between Main Street and the canal in 1850. It manufactured high quality timepieces that carried the name Ansonia all over the world. The original factory burned in 1854, though it was rebuilt in stone and enlarged by 1861. The company moved to Brooklyn, New York, in 1881, but retained the name "Ansonia." Since the name continued to be clearly marked on the clock faces, stories about them filtered back to town for years after the company left. Such stories include a town in Ohio that found it had the same name as another in that state and had to change. The town fathers changed the name to "Ansonia," liking the sound of the brand name of the clock on the post office wall. This photo shows the Clock Company's display at the Chicago Exposition in 1893. The clock machinery was sold to Russia in the 1930s. However, the machinery was returned to America via Japan, and a new Ansonia Clock Company began manufacturing the old patterns in Lynnwood, Washington, in 1970.

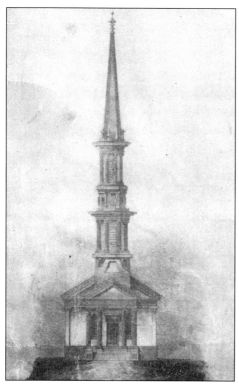

Ansonia received its own Congregational church parish in 1850, most of the members having come from the old Derby church. Anson Phelps donated the land upon which the first church was built. The new church, which was a small frame building with a large steeple, was dedicated in 1852. The building served the First Congregational Church of Ansonia until fire destroyed it in October of 1863. (Ansonia Library.)

The First Congregational Church of Ansonia quickly rallied after fire destroyed its old church. A stone church was constructed on the same site on South Cliff Street. The new church was dedicated May 25, 1865. The bell and weathervane were both salvaged from the old church and added to the new. This beautiful landmark continues to serve its congregation today.

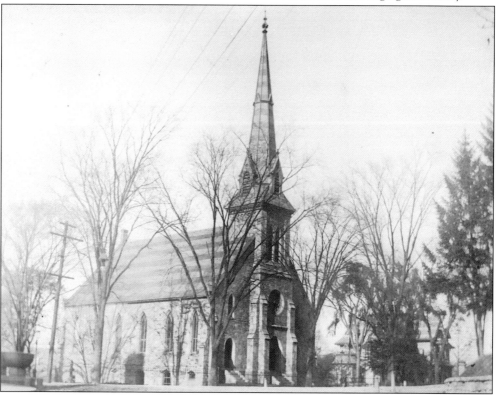

Like the Episcopalians and Congregationalists, Ansonia's Methodists had to travel to Derby before their own church was established in 1851 with 61 members. The first church was a building on Main Street with two stores on the first floor and a hall on the second. In 1866, the building pictured here was dedicated on upper Main Street. This landmark served its faithful until it was destroyed by fire in 1943.

Sperry Manufacturing Company was founded by Wales Terrell in 1865 on Beaver Street. They manufactured carriage hardware, including saddle and clip springs, joint ends, and steps. At one point, they were the largest producers of fifth wheels in America. In 1901, the building was purchased by the H.C. Cook Company, which manufactured nail clippers. The old buildings were replaced in 1919 with a brick plant. Note the poultry in the foreground.

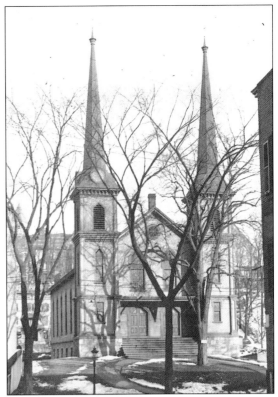

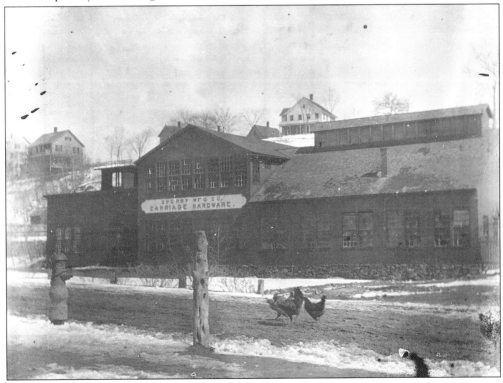

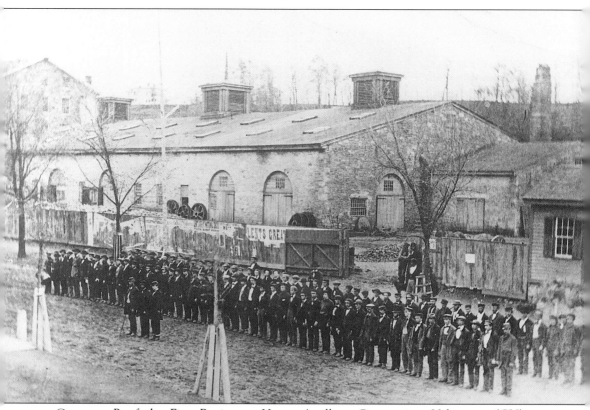

Company B of the First Regiment, Heavy Artillery, Connecticut Volunteers (CV) was composed entirely of Ansonia men at the start of the Civil War. Commanded by Captain Elisha Kellogg, the company trained in front of the old, original copper mill built by Almon Farrel in 1844 for Anson Phelps. To the right of the mill is part of Ansonia's old schoolhouse. This picture was taken just before the men left for Hartford, where they were mustered into the U.S. Army on May 22, 1861. Captain Kellogg was promoted to lieutenant colonel and transferred to the newly formed Nineteenth Infantry Regiment, CV. He was later moved to the Second Regiment, Heavy Artillery, CV, as a full colonel. He was killed on June 1, 1864, at the battle of Cold Harbor. Five hundred and forty-two men from Derby and Ansonia participated in the Civil War; almost ten percent of the 1860 census population of 5,443.

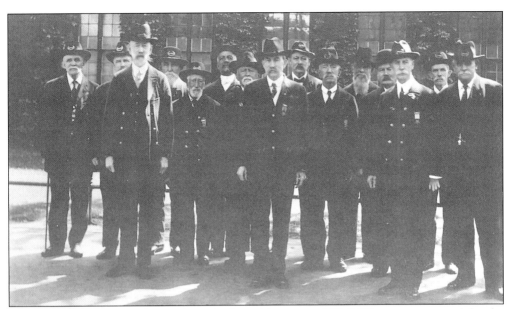

The guns had long since been silenced when this group of Civil War veterans posed for the photographer along Main Street. Pictured here are, from left to right, as follows: Ewald Kupper, W. Curtiss, Walter Hazard, Charles Buckingham, Clark Davis, Charles Tatten, Samuel Blair, Horatio Brown, Dwight Seegar, George Bisbee, George Bartlett, Charles Snow, James Ould, George Lyon, and Henry Alling.

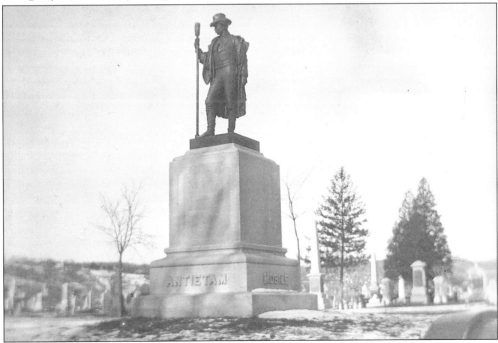

Ansonia's Civil War Monument was dedicated in 1876 in Pine Grove Cemetery on Church Street. Perched atop a granite pillar depicting battles during which Ansonia men fought and died, the soldier appears to be an artilleryman, rather than the usual infantryman. This is an obvious tribute to the many Ansonia men who served in the Heavy Artillery companies.

Main Street looking north, is shown here, just below Bridge Street. The building in the left foreground was called the Blackman building, the eagle placed upon its roof around 1852. Mr. Blackman, a pacifist, was very vocally opposed to the Civil War, which caused much bitter feeling against him. He chose to express his views by painting upon the eagle's wings "O Liberty, what Crimes are Perpetrated in Thy Name!" One night, soon after the war began, someone placed the flag of secessionist South Carolina upon the roof of the building, and covered the eagle with sacks, to mock Mr. Blackman's pacifism. Charles Nettleton, who lived in the building, returned home from work late that night. Seeing the flag and sacks, he rose Mr. Blackman, and they and others removed both. As they did so, people threw stones at them from the nearby Hotel Ansonia, causing Nettleton to draw his revolver to make them stop. Fearful of further violence, Mrs. Blackman's niece stayed up all night knitting an American flag, which was fluttering above the eagle by dawn, ending the violence. The eagle's lettering was changed to the more sedate "Victory to the Peacemakers!" The eagle is now perched atop Eagle Hose Company's firehouse. (Ansonia Library.)

One of the earliest predecessors to Union Trust Bank, the Bank of North America moved from Seymour to Ansonia in 1861, changing its name to the Ansonia National Bank. Banks issued their own currency before a national standard was developed. These bills were printed by the bank in 1862. Local hero David Humphreys is pictured in the lower right hand corner of the one, two, and five-dollar bills.

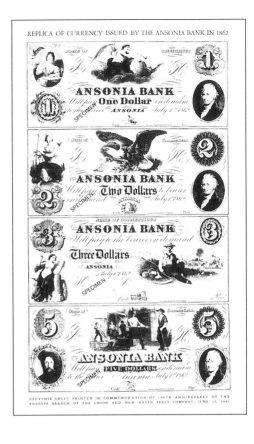

A mutual savings bank, the Savings Bank of Ansonia was chartered in 1862. It used to operate in a building shared by the Ansonia National Bank on 165 Main Street. In 1891, a lot at 117 Main Street was purchased. The bank's new building, pictured above, was erected in 1900.

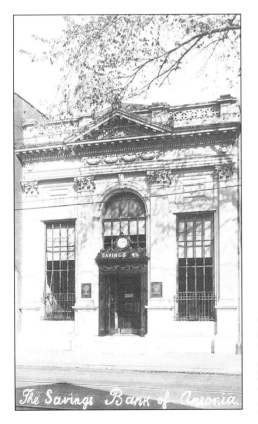

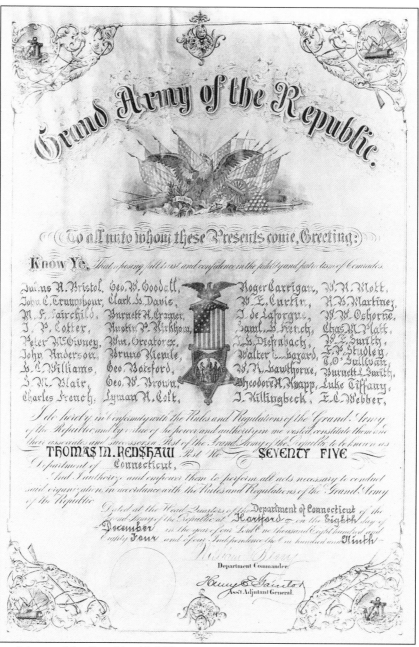

The Grand Army of the Republic (GAR) was a nationwide organization composed of surviving Civil War veterans. The Thomas M. Redshaw Post 75 was organized in Ansonia on December 8, 1884. The GAR was very influential in town affairs in the second half of the 19th and in the early 20th centuries. They were prominent in the "Americanization" movement, which helped new immigrants assimilate themselves. It was the GAR that first marked and observed Decoration Day, which we know today as Memorial Day. Unlike later veteran organizations, the GAR only admitted veterans from the Civil War, so that by WW II, organizations like the Thomas M. Redshaw Post had become extinct. This photograph is a copy of the document establishing the new Ansonia post. (Ansonia Library.)

Three

BOROUGH OF ANSONIA

Ansonia was incorporated as a semi autonomous borough within the town of Derby on August 1, 1863. Birmingham was also a borough within the town at the time. By this time, Ansonia was quickly developing into a self-sustaining community. This view from Tremont Street hill shows the canal's millpond at the bottom of the picture, while the canal bank itself is jammed with factories. Church steeples rise above hill on South Cliff Street to the right.

The Ansonia Opera House, which was on the third floor of this building on 100 Main Street, was completed in 1870 at a cost of $40,000. The stage and location were considered excellent by the traveling companies that performed there in the 1870s. However, as transportation services improved, Ansonians patronized larger halls in larger cities like New Haven. The Opera House continued to be used for meetings, dances, movies, socials, and even basketball and roller-skating!

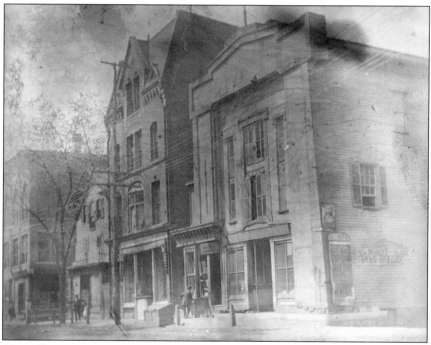

The GAR Hall was located on 152 Main Street, the building on the right. The store on street level housed Lockwood Hotchkiss, which sold hardware, paints, oils, cement, lime, glass, putty, and cordage. In 1865, French immigrant Pierre Lallement rode his new "velocipede" for the first time down Main Street. The following year he received a patent for it, the first issued to manufacture bicycles in the country. (Ansonia Library.)

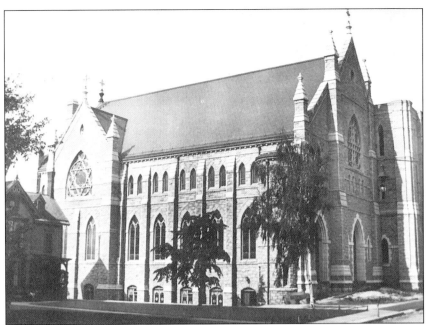

A Roman Catholic Sunday school was formed in 1853 and reflected the increased numbers of Irish immigrants living in Ansonia. The first Roman Catholic parish was organized in 1868 on the Feast of the Assumption, becoming the Church of the Assumption. The original church was on Main and Cheever Streets. The second church on North Cliff Street, pictured here, took 18 years to build before being dedicated in 1907.

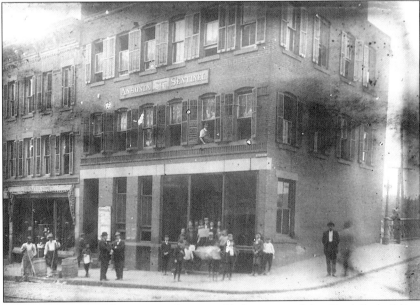

The weekly *Ansonia Sentinel* newspaper began publishing out of the Gardella building on the corner of Main and Maple Streets in 1871. It began publishing daily, and renamed itself the *Evening Sentinel* in 1884. It then became the only newspaper in the Valley when the *Derby Transcript* closed in 1902. A new building was erected next to city hall in 1905. The paper was closed in December of 1992, leaving the Valley without its own daily newspaper.

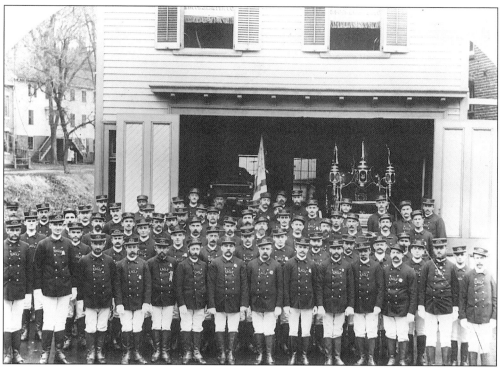

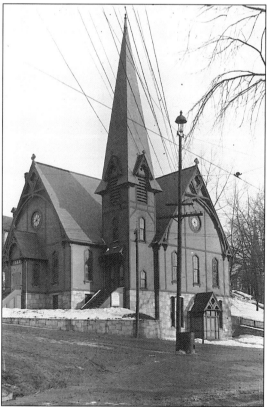

Ansonia's first fire company, the Eagle Hose Hook and Ladder Company, nicknamed "Big Six," organized in 1871. The first hose house, pictured here in 1906, was located on North Main Street. Two of the hand-drawn "jumpers," or hose reels, are to the rear of the men. The ornate parade carriage behind on the right is still preserved by the fire company to this day.

The First Baptist Church was organized on January 28, 1874, with 39 members who met in the YMCA in the Opera House. Its church was dedicated on May 31, 1881, on East Main and State Streets. By this time, the membership had swelled to 228 members. The Ansonia Church is the parent church of the First Baptist Church of Shelton (1882), the Macedonia Baptist Church of Ansonia (1890), and the Italian Mission of Ansonia (1913).

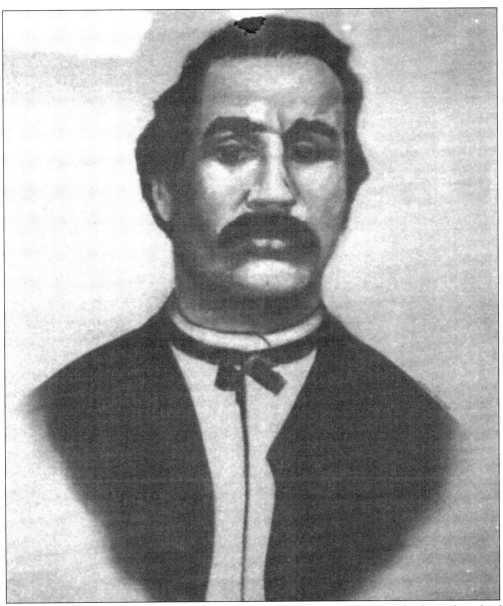

Daniel I. Hayes was born in Ireland in 1846. Settling in Ansonia, he became the first police chief of the borough when the force was organized in 1880. On December 23, 1880, Chief Hayes was summoned by the father of James "Chip" Smith, asking him to arrest his son after he discharged a pistol in a saloon. He had also threatened an Osborne & Cheeseman foreman and his own mother. The chief found Smith near the Railroad Hotel on Main Street. A struggle ensued, and Hayes was shot in the stomach. Oblivious to the wound, Hayes and a passerby subdued Smith, and brought him to the lockup on 40 Water Street. Hayes's condition deteriorated, however, and he died of his wound on December 27. During the ensuing trial in New Haven, Judge John Duane Park avoided a potential deadlock by instructing the jury to make every effort to reach a unanimous decision. The procedure is still known as the "Chip Smith charge" in Connecticut. Smith was found guilty and executed in 1882. The office of police chief was vacant in Ansonia until 1883. (Ansonia Police Department.)

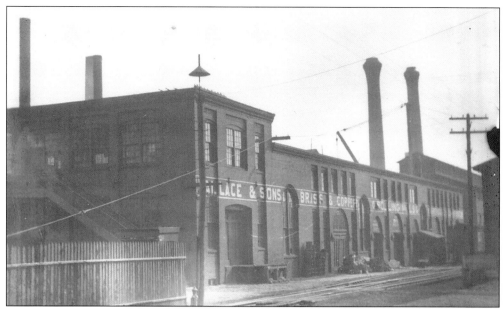

Thomas Wallace's son William (1825–1904) performed experiments in electricity, particularly carbon arc lights. They were first tested one night on the 206-foot brass mill chimney, the tallest structure in Ansonia, flooding the town with light and startling residents with illumination as far as Division Street. Thomas Edison visited William in Ansonia in 1878, purchasing two generating devices from him called "telemachrons." Ideas from these devices, Edison acknowledged, led him to produce the first incandescent electric light.

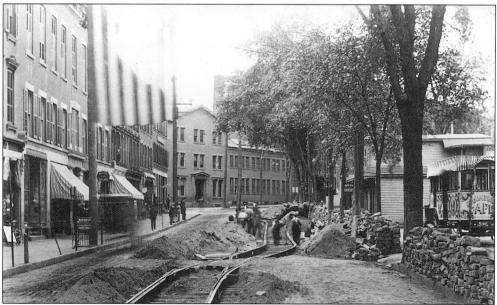

William Wallace continued to remain interested in electricity, and in 1885 was one of the founders of the Derby Horse Railway. Trolley tracks were laid along Main Street, connecting Ansonia with the Derby docks and Birmingham via East Derby. In 1887, the line became the first electrical trolley system in New England. The company changed its name to the Derby Street Railway in 1889.

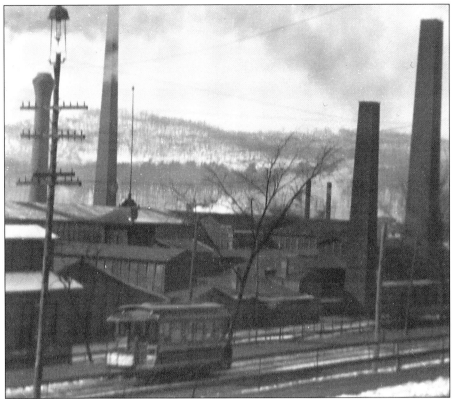

Electric trolley service began in Ansonia in December of 1887. With the purchase and electrification of the Birmingham and Ansonia Horse Railroad Company in 1889, a beltway was established between Ansonia and Derby. The light at the top left is one of Wallace's carbon arc lights. Coe Brass, which later became Anaconda American Brass, is behind the trolley.

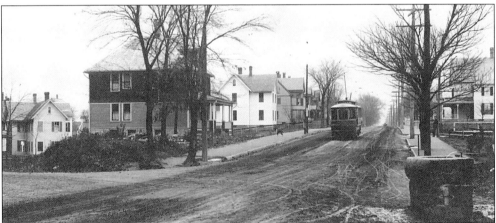

The electric trolley service was extended to Seymour along Wakelee Avenue in 1901. A Seymour-bound trolley passes along Wakelee Avenue near Franklin Street shortly after the line opened. The line would later be extended to Waterbury, greatly increasing communication all along the Naugatuck Valley with affordable, reliable transportation. The working watering trough in the right foreground indicates the day of the horse was still not quite done. (Ansonia Library.)

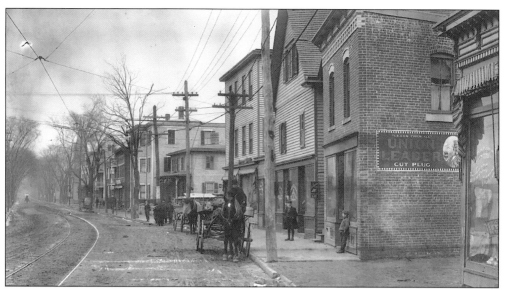

Not a single building in this picture of lower Main Street looking north, including the original Church of the Assumption (later Holy Rosary Church) behind the trees, exists today. The neighborhood consisted predominantly of "cold water flats"—multi-family tenement buildings so named because they lacked hot running water. Mostly immigrant families who toiled in the factories lived here.

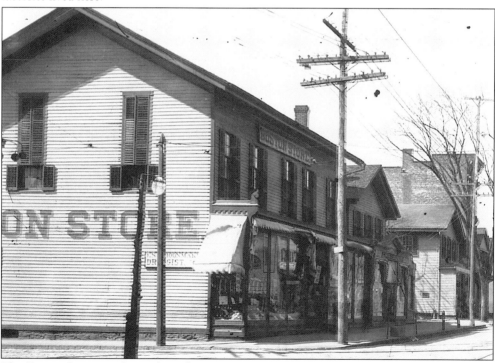

The Boston Store was located on the corner of Main and Bridge Streets. The store replaced its building with the three-story Murray Block, built in 1905, at the same location. The store sold "dry and fancy goods" according to a 1904 advertisement. In 1907, it boasted itself as "the shopping mart of Ansonia and vicinity." Next door was the Ansonia Market.

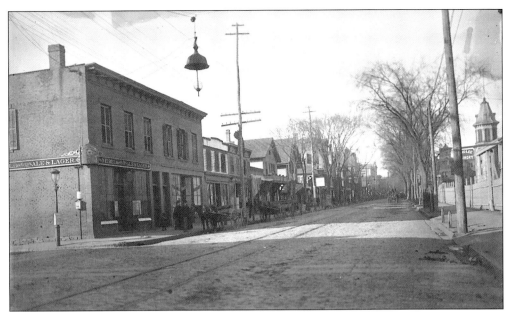

This image looks north in this early view of the corner of Main and Water Streets. W.P Fitzgerald Wine and Liquors occupied the corner store at 260 Main Street. Behind the first left telephone pole was Walsh Brothers Coffee and Teas at 246 Main. The second telephone pole on the left sports a white "Livery" sign, where Thomas D. Lindsay's stables were located. Wang Lee's Chinese Laundry was across the street.

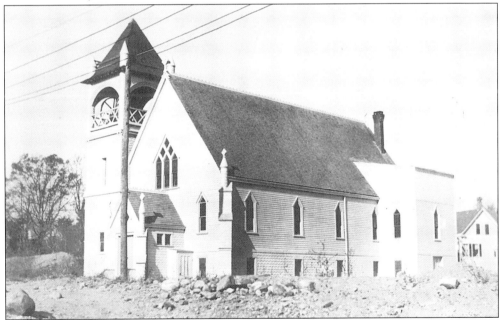

Emanuel Episcopal Church celebrated its first Mass on Palm Sunday, 1887. Located on Church Street and Howard Avenue, it was the first church in the growing suburb of West Ansonia, across the river from downtown. The church had to be moved to a lot west of the present church due to a change in street grade in 1900. The wood frame church pictured here was replaced by the present beautiful stone edifice in the mid-1930s.

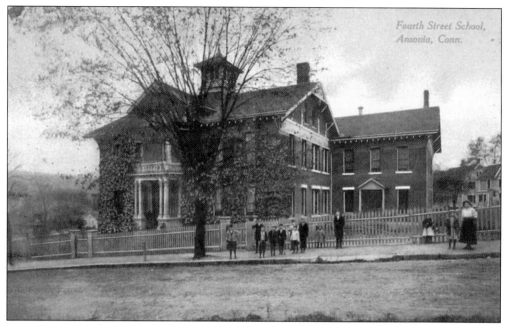

The increase in Ansonia's population meant a growing number of public schools were built. First called the New Brick School, the Fourth Street School was built in 1883. The school was renamed the Andrew Nolan School, in honor of Andrew Nolan, Ansonia's mayor from 1936 to 1945. Mayor Nolan attended the Fourth Street School as a child.

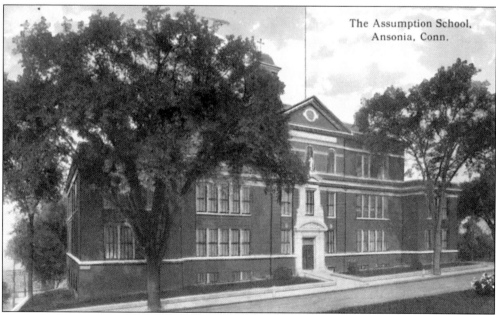

Ansonia's first parochial school was opened by the Church of the Assumption in 1886, on the first floor of the Sisters of Mercy's Factory Street convent. In 1890 and again in 1908, the school and convent both moved to former residences. Finally, the Assumption School building on North Cliff Street, pictured here, was dedicated in 1910.

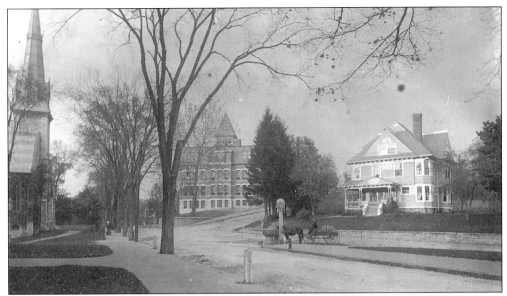

Pictured is the junction of Cottage Avenue, South Cliff Street, and Prospect Street. The stone Ansonia Congregational Church is to the left. The Ansonia High School occupies the center of the picture, while the house on the right is the Congregational Parsonage. The Ansonia Library would be built across the street from the Parsonage. Note the horse watering at the trough on South Cliff and Cottage. The trough remains today.

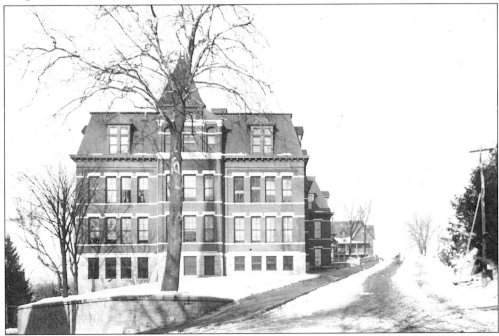

Ansonia High School, on the corner of South Cliff and Prospect Streets, was reconstructed in 1890 from the former Hill School, which had occupied the site. The Hill School was a six-room wood frame building constructed in 1862 and was continually enlarged. Nearly 50 years worth of scholars were educated here before the school was destroyed in a terrible fire on February 23, 1939.

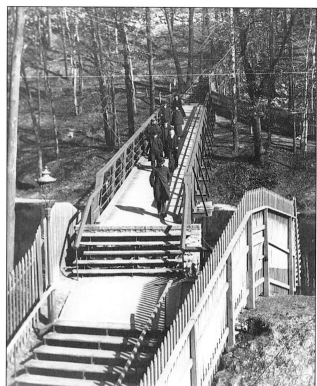

"The cliffwalk," constructed before 1883, allowed residents of South Cliff Street and other streets atop the hill to traverse safely the steep bluff into downtown without having to take the circle route from North Main Street. The walkway also crossed the Ansonia Canal. The cliffwalk quickly became a busy pedestrian thoroughfare, especially before the widespread use of automobiles.

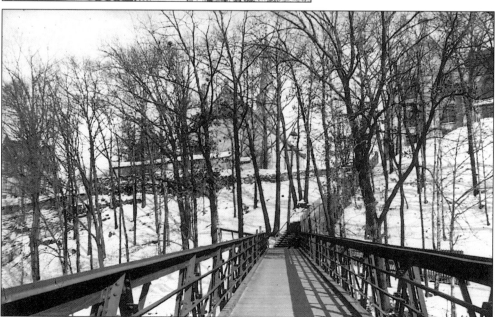

This photograph was taken near the top of the cliffwalk, on a cold, wintry day around 1900. The bottom of the walkway began at Main Street, while the top terminated between the Congregational Church and Christ Episcopal Church. The walkway also allowed people in the commercial and industrialized Main Street area easy access to the high school and library at the top of the hill.

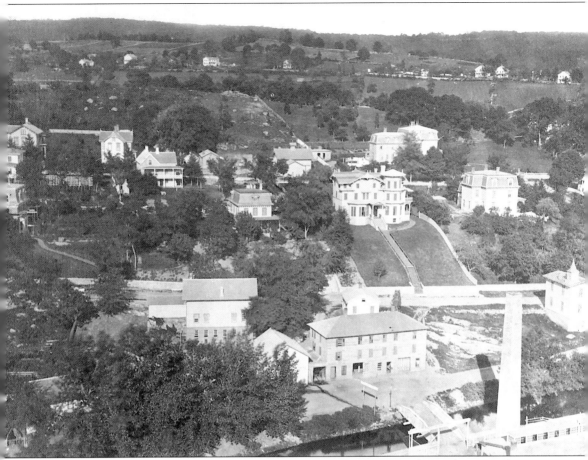

This very interesting photograph appears to have been taken by an airplane, when in reality it was shot from the top of the 206-foot chimney at the brass mill. (This is the same chimney from which William Wallace lit up Ansonia as he performed his arc light experiments.) The photo was taken in 1877. The Ansonia Canal is on the bottom right. The street opposite the bridge is Liberty Street. This bridge allowed access into the "brass mill yard." Beyond Liberty Street is North Main Street. The small North Main Street building to the right of the smokestack was the Eagle Hose Company's first firehouse. Behind North Main is North Cliff Street. At the time this picture was taken, there were no streets between North Cliff and distant Prospect Streets, which link the farmhouses in the background.

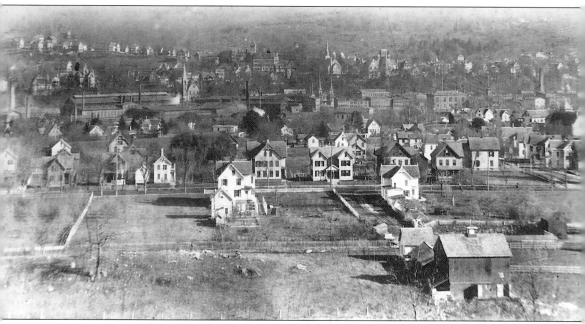

This panoramic photograph taken from Silver Hill shows the rapid development of West Ansonia, as well as significant landmarks across the river. The church in the center left is the First Baptist Church. The twin steeples of First Methodist rise just below the Congregational Church up the hill on South Cliff Street. The new Christ Episcopal Church can be seen to the right of the Congregational Church, while Ansonia High School is to the left. The works of Farrel Foundry and other mills are in the center left of he picture, while the commercial buildings and blocks of Main Street are in the center right. The Ansonia Opera House appears as the largest building in the business district. Note the horse barn in the foreground right. It appears that this photo was taken from a Wakelee Avenue backyard, just above Jackson Street.

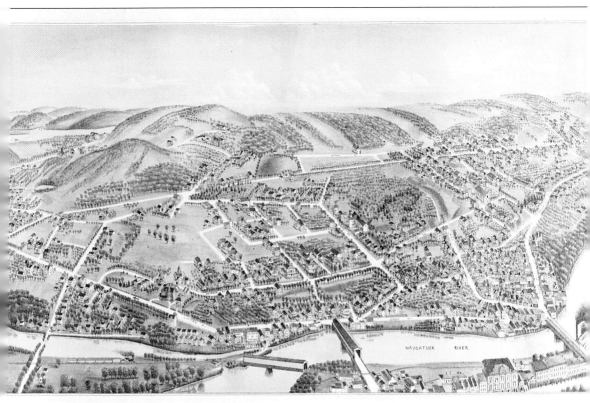

WEST ANSONIA.

CONNECTICUT

1887

This is an 1887 lithograph of West Ansonia. No less than three covered bridges cross the Naugatuck River at this point: Maple Street to the right, Bridge Street in the center, and a bridge built for the Naugatuck Railroad to the left. All would soon be replaced by concrete bridges. A fourth bridge, the private American Brass Company Bridge, was north of the Maple Street span and has not yet been built. The apparent branch of the Naugatuck River near the bottom is actually the beginning of the Birmingham canal, which was dug in the 1830s. Pershing Drive was built upon the old Birmingham canal after it was filled in. The street winding down the steep hill on the lower left is today's Division Street, the canal occupying what will some day become a busy intersection. The hills beyond are Derby, while those across the Housatonic River on the upper left comprise Shelton.

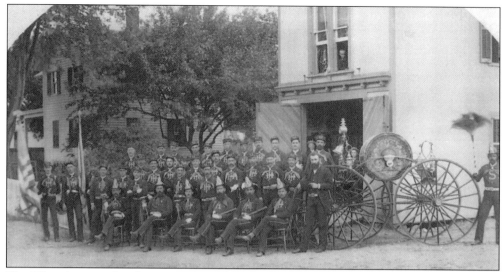

The West Ansonia fire district was established on June 3, 1875. The firehouse on the right, at the corner of Franklin and Arch, was built later that year and fire equipment bought. The Fountain Hose Company No. 1 was organized to operate out of the firehouse on February 12, 1876. The company still possesses the parade carriage on the right, purchased on April 12, 1879. (Fountain Hose Company.)

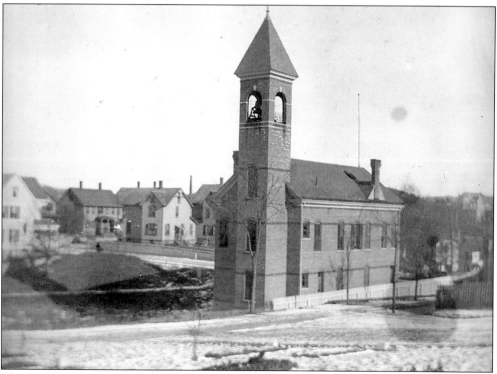

The fire company was probably named after Fountain Water Company, which was organized in 1872 to provide water to West Ansonia. It merged with the Ansonia Water Company in 1926. In 1891 the present hose house, the rear of which is pictured here, was completed. This photograph was taken from Pine Grove Cemetery, established in West Ansonia in 1856.

The Grove Street School was the first school in West Ansonia when it was completed in 1865. The original building, the portion to the left, contained only two rooms. Miss Julia Pickett was the first teacher at the school. She was also the first teacher at the old schoolhouse next to the copper mill on Main Street. Grove Street School was later renamed Willis School after Principal Minnie E. Willis.

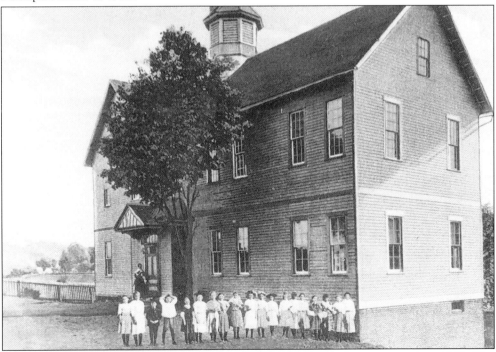

Students and teacher pose in front of the School Street School, constructed in 1882. The school initially handled the overflow students from Grove Street and Holbrook Schools. When the street was renamed Westfield Avenue, the name of the school was changed accordingly. The school was closed in 1937.

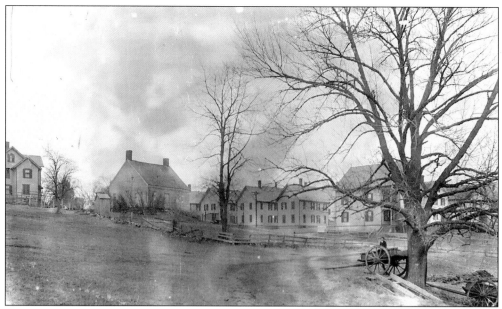

This old photograph was taken from Myrtle Avenue looking toward Beaver and East Streets. The houses in the center were of new construction when the picture was taken, while the cape in the left center was of older construction. All of the houses, except the cape, still stand today.

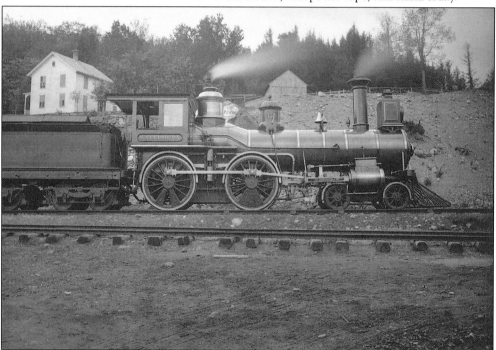

Engine No. 12 and its coal tender are building up a head of steam on the old Naugatuck railroad line in Ansonia. The name of the engine was the "Waterbury." The sound of steam whistles, be they on the local factories or the locomotives entering and leaving town, were a familiar sound to generations of Ansonia residents. The New York, New Haven, and Hartford would eventually buy the old Naugatuck Railroad line through Ansonia.

Four

THE BLIZZARD OF 1888

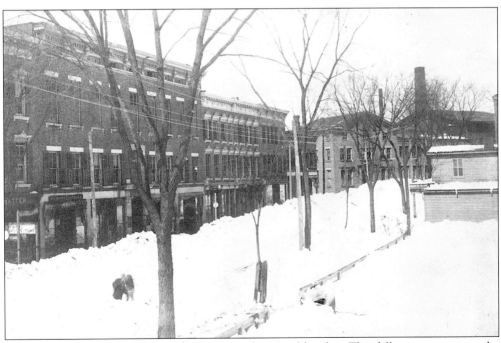

March 10, 1888, was an unusually warm and spring-like day. The following morning, the temperature dropped, and high winds and heavy snow continued into the next day. By noon on March 12, visibility was near zero. Huge snowdrifts were left piled up to the second floor of some buildings in the storm's wake. The top of Main Street, looking toward Farrel's, is buried here.

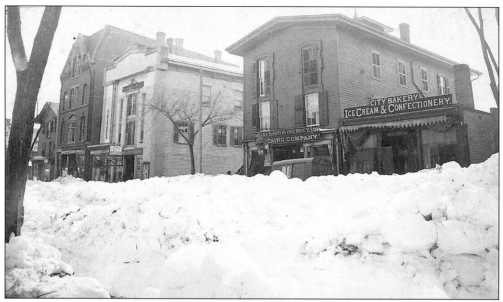

The City Bakery at 136 Main Street probably didn't sell much ice cream the day after the blizzard, when this picture was taken. The Boston One Price Clothing Store was next to City Bakery in 1888. The lighter colored Masonic Hall lies beyond on 152 Main Street. The four-story building next door was a hotel. (Ansonia Library.)

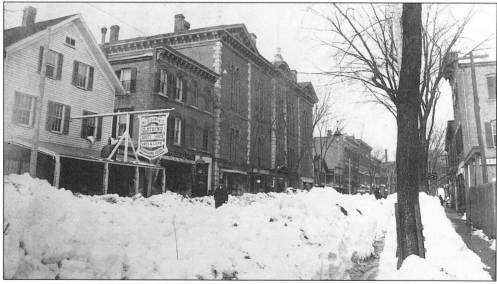

A man stands amid the snowdrifts in the middle of Main Street. The large building behind him is the Ansonia Opera House. The clothing store of W.A. Fellows & Co. occupied the white building on the left foreground. Paths are shoveled through the snow on the sidewalk and the street is only wide enough for pedestrians.

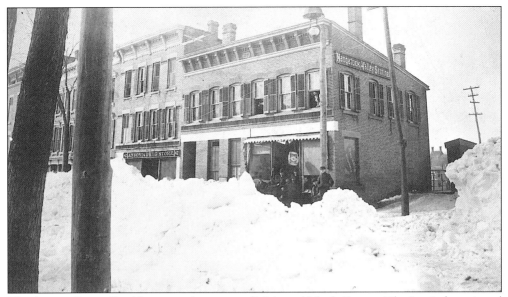

The *Ansonia Sentinel* building is on the corner of Main and Maple Streets. The *Sentinel* continued publishing despite the heavy drifts in front of its building. The Maple Street bridge lies behind the building. The Ansonia Drug Store is next door at 42 Main Street. Recognizing the Blizzard as a once in a lifetime event, the newspapers covered it extensively, calling it a "Nineteenth Century Wonder."

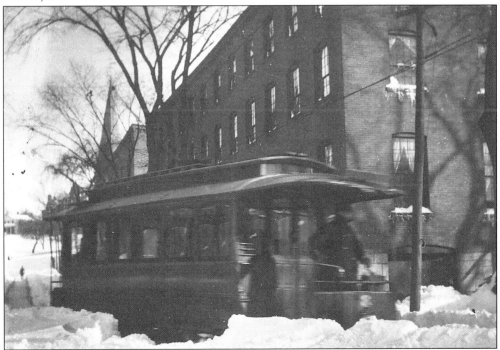

A new Ansonia, Derby, and Birmingham trolley car negotiates the tall drifts on the corner of Main and Maple Streets. Both trolley and rail transportation was paralyzed immediately after the storm. Only after immense efforts were the trolley tracks cleared. Many trains were snowbound in high drifts all along the northeast, leading to some fatalities.

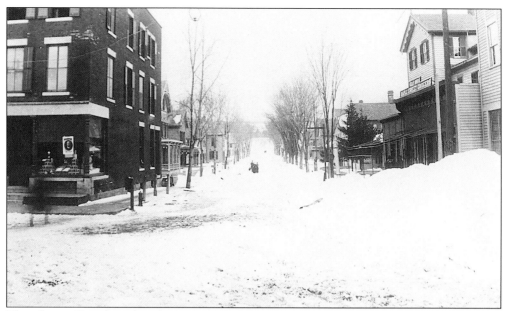

This photo of Maple and High Streets in West Ansonia provides an excellent example of how the windblown snow drifted after the blizzard. The left side of the street is relatively free of snow, while the snow is piled above the windowsills on the right. The three-story block on the left contained George May's grocery store. Across the street (minus an awning that may have blown off during the storm) is Maple Street Grocers.

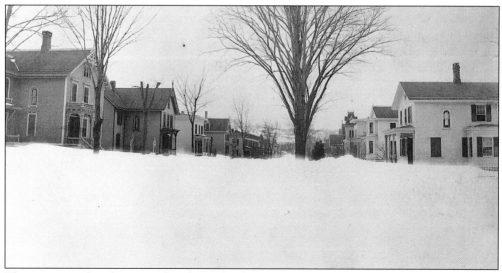

The morning after the storm found South Cliff Street looking desolate and isolated, as seen in this picture. Like many other neighborhoods and communities in the northeast, residents here were pretty much on their own. There had been no warning of this major blizzard, which dumped snow that, thanks to the wind, drifted to 20 feet in some spots.

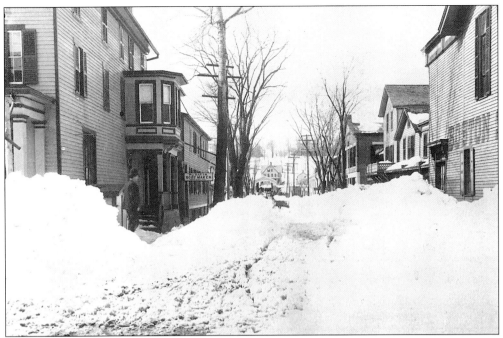

Looking down Bridge Street, south of Main, the entrance to the covered bridge can be seen in the background, in the center of the picture. The sign for boot maker William Davis's small shop is visible on the left. The building in the right foreground was the Boston Store. Houses way in the background are across the river in West Ansonia.

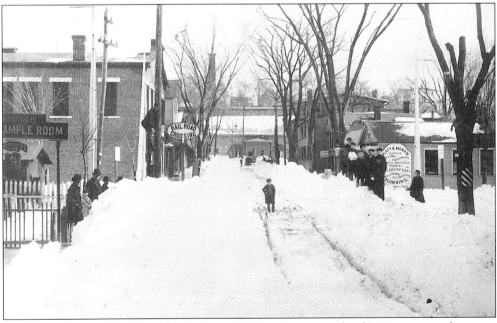

The bystanders on the right of this view of Bridge Street, north of Main, are standing atop snowdrifts. Those on the left on street level are almost completely obscured, with the exception of the boy climbing the telephone pole. By this time, horse-drawn sleighs were traversing the street. The building in the background was the original copper mill built for Anson Phelps.

Their hand-drawn hose reels idling uselessly in the hose house, the men of Eagle Hose, Hook and Ladder Company loaded a hand-drawn sleigh with hose. Meanwhile, others carried the ladders by hand, in the event an east side building caught fire after the blizzard. Fortunately, no fires occurred in Ansonia while the borough was snowbound. This photo was taken on State Street.

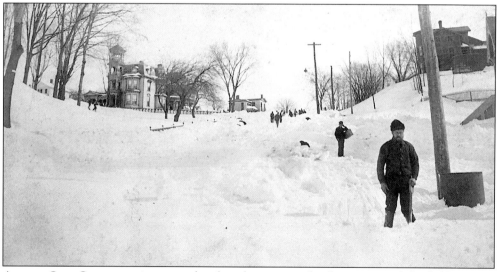

A weary State Street man interrupts his shoveling to pose for the camera, while children have the time of their lives in the background. The same year the blizzard occurred, 1,100 borough residents signed a petition asking that Ansonia separate from Derby and form its own township. Despite fierce opposition from Derby, the Connecticut General Assembly granted Ansonia its independence a year later.

Five

THE CITY OF ANSONIA

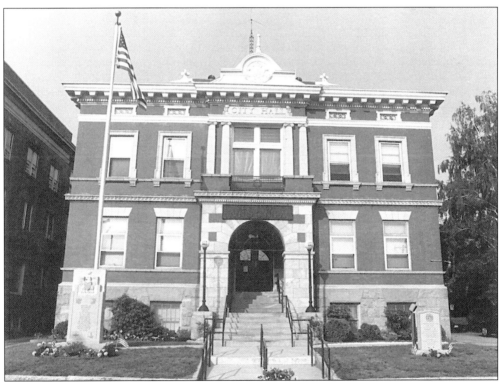

Ansonia became a township independent from Derby in 1889. The cumbersome town-borough arrangement was maintained only until 1893, when the present municipality with the Mayor-Alderman-type government was formed. Ansonia City Hall, pictured here at 253 Main Street, was constructed in 1905. It continues as the seat of Ansonia's government to the present day. (Ansonia Library.)

Arthur H. Bartholomew was Ansonia's representative to the State General Assembly in 1893. He was instrumental in getting the town's city charter granted that year. A local manufacturer, Mr. Bartholomew was elected the new City of Ansonia's first mayor on November 8, 1893. The same election saw Mrs. Estella J. Mills elected to the board of education, one of the first women to hold office in New England. Mayor Bartholomew served until 1895.

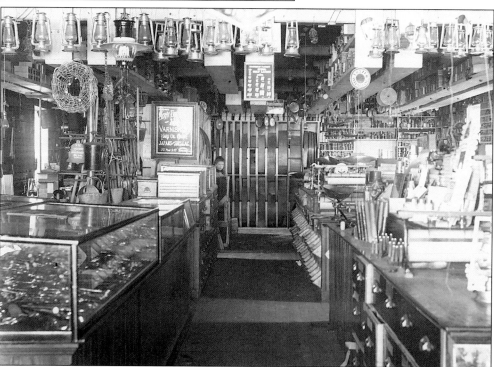

The mainstay of downtown were the shops and stores which lined the broad avenue of Main Street. Woody Hotchkiss's hardware store on 246–250 Main Street was such an example. A young girl peeks around a corner in the rear of the shop as the photographer captures the image of the store loaded with useful stock and provisions.

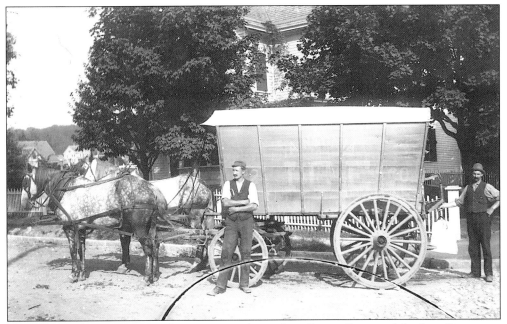

The barns of the Ansonia Ice Company were located on Beaver Street, while the office was at 100 Main Street. Two employees pose in front of one of the ice company's wagons; the man on the right holds a sample block of ice. In the days before electric refrigeration, ice deliveries were common. Stores, businesses, factories, railroad cars, and homes that required cold storage were all counted as customers.

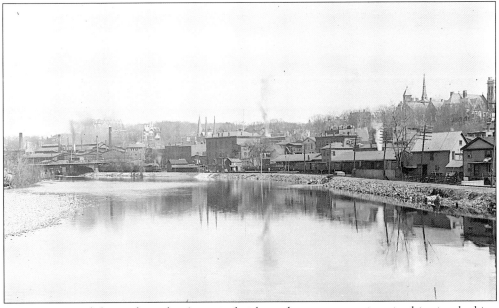

Trains arrive and depart from the Ansonia freight and passenger stations in this view looking north up the Naugatuck River about 1900. The smokestacks at the left belong to Farrels and American Brass Company, of which Ansonia Brass and Copper Company was a founding firm. Above the smokestacks, the frame of the incomplete Church of the Assumption can be seen. The bridge spanning the river is the new Maple Street span.

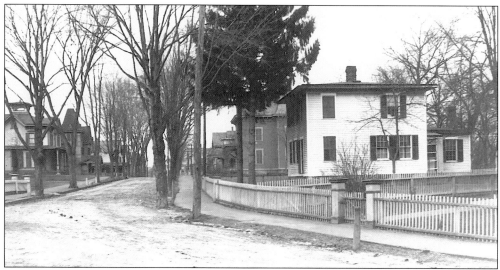

A c. 1900s view of Lester Street looks North from Grove Street. Both streets remained unpaved at the time the photograph was taken. The house on the right side, 12 Lester Street, has since been enlarged. Lester Street was one of the first residential neighborhoods in West Ansonia.

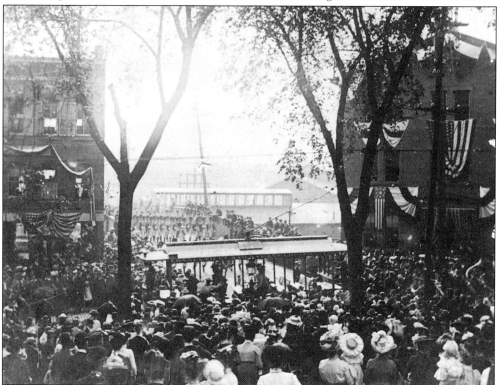

An image reproduced from an old stereoscopic photograph depicts a parade coming across the new Maple Street Bridge onto Main Street. The trolley in the center was an open model, allowing the breeze generated by its movement to cool passengers in the summer. The Connecticut Railway and Lighting company bought the Derby Street Railway in 1900. Its logo on the roof of the trolley indicates this picture was taken after that time.

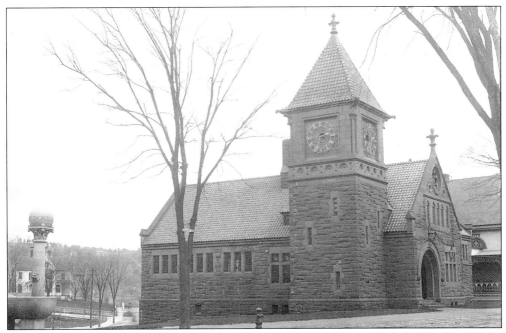

The Ansonia Library at 56 South Cliff Street was presented to the town by Miss Caroline Phelps Stokes in memory of her parents, as well as her grandfather—town founder Anson Phelps. The watering trough, seen at left, was given in memory of Anna Sewell, author of *Black Beauty*, for whom Mrs. Stokes had great admiration. The trough still exists there today.

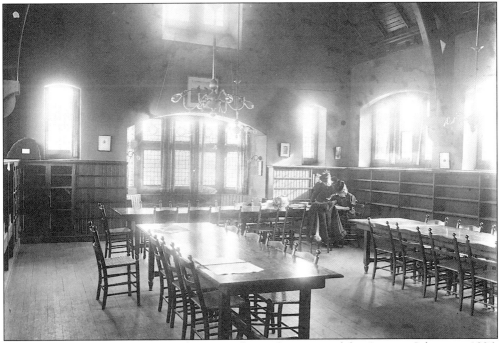

Miss Olivia and Miss Caroline Stokes sit in the reading room of the Ansonia Library in 1896. The library began construction in April of 1891. It was dedicated on June 9, 1892, and became a free library in 1896. The library began with a collection of 1,515 books.

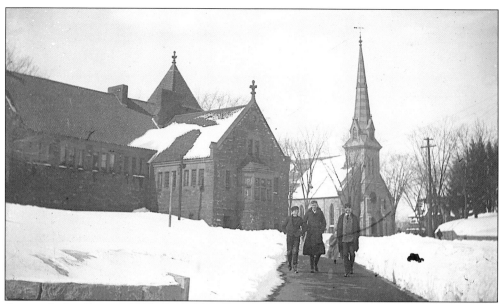

A trio of schoolboys, possibly from the Ansonia High School outside the picture to the right, stride down a wintry Cottage Street. Perhaps they were attending church at the Ansonia Congregational Church, immediately behind them. The Ansonia Library is in the left foreground. Christ Church has yet to be built in this photo dated about 1893.

Macedonia Baptist Church was organized by members of Ansonia's African-American community on May 5, 1890. The church pictured here was constructed in 1892. The church was originally located at 24 Clifton Avenue, but with the rearrangement of the roads after Pershing Drive was constructed, the address is now 243 Pershing Drive. The edifice continues to serve its members more than a century after its completion. (Markanthony Izzo.)

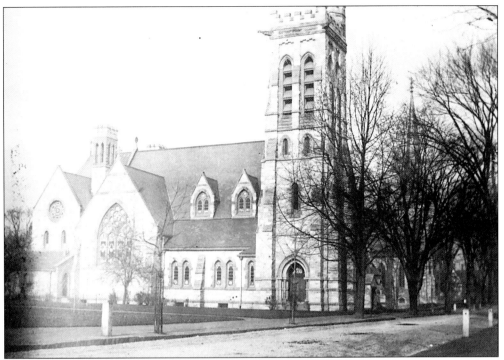

Ground was broken for Christ Episcopal's new church on September 13, 1893. The impressive new stone edifice was consecrated on January 17, 1900. The church continues to serve its parish at that location to this day. Located on 56 South Cliff Street, the church is across from the Library and next to Ansonia Congregational.

High Street is pictured as seen from the Fountain Hose Company bell tower, on December 31, 1899. The backyard of the house in the center is visible, which is rare in 19th-century pictures. The large structure just behind the house is the carriage barn, while the small one to the left of it are the "privies," or outhouses.

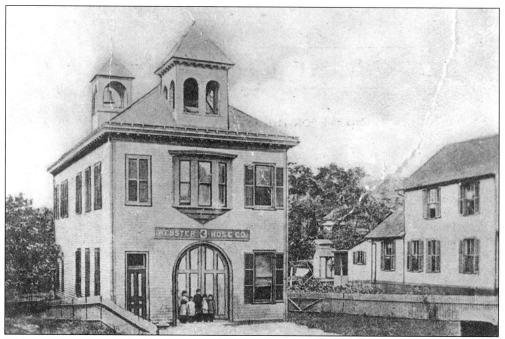

Webster Hose Hook & Ladder Company No. 3 was formed in 1897 and named after Ansonia's second mayor, Edwin W. Webster. Originally containing a hand-drawn hose reel, their 67 Platt Street firehouse was completed the same year. Its location atop the hill was advantageous to the men who had to pull the reel. The firehouse was later replaced by the current brick two-bay building at the same location in 1937.

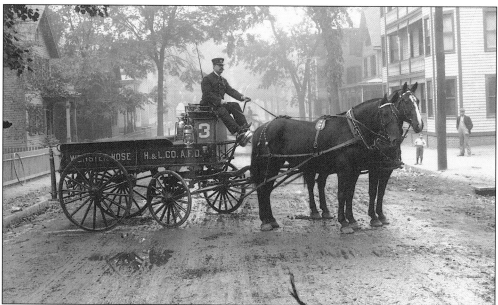

In 1907, saloon owner and Webster member James "Jaspy" McKewen purchased Ansonia's first horse-drawn hose wagon. His own horses "Mollie" and "Dollie" pulled the new wagon from his garage at 63 Central Street. This photo was taken December 19, 1907. The Central Street firehouse augmented the Platt Street one until 1937.

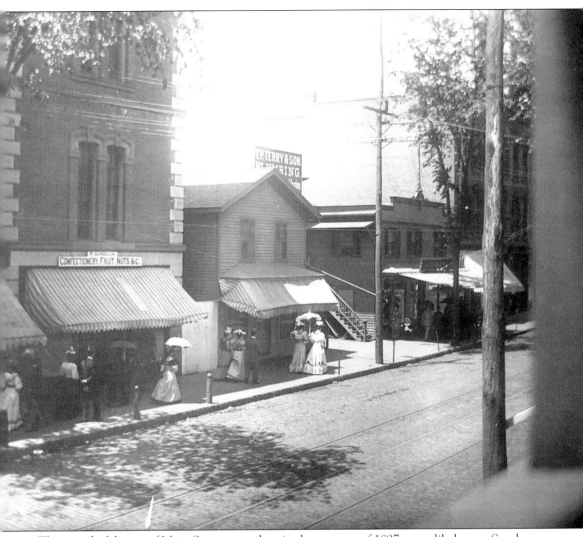

This wonderful view of Main Street was taken in the summer of 1897, most likely on a Sunday. Judging by the women's light-colored clothing and parasols, it is a hot, sunny day. The large building on the left is the Ansonia Opera House, with Pasquale Gardella's fruit, nut, and confectionery stand the only store visible in the picture. The two-story building next door contained a millinery run by Mrs. Frances Lum. The building beyond that, with the large sign on top, was the T.P. Terry & Son store, which sold stoves, crockery, and plumbing supplies. Terry's Block would shortly be built where the two smaller buildings are pictured. Main Street was paved with wood blocks to allow easier transport of heavy loads around 1888. This photograph was probably taken from a window at Gardner's Block, which was across from the Opera House at 87–99 Main Street. (Ansonia Library.)

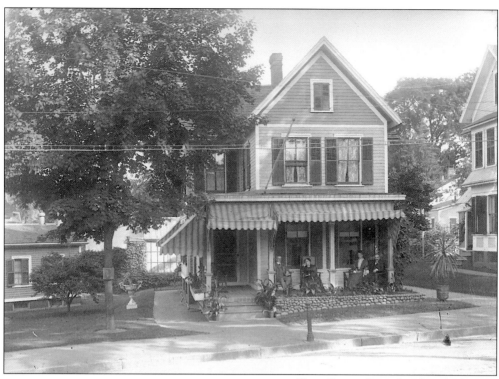

Clara Barton Drew lived in the house pictured here at 26 New Street. In the early 1900s, she obtained her first camera and quickly developed a hobby for picture taking and developing. She continued to grow more talented, becoming one of the first female professional photographers. This photograph was taken in 1909, while she had a very special visitor seated second from left on her porch (see below).

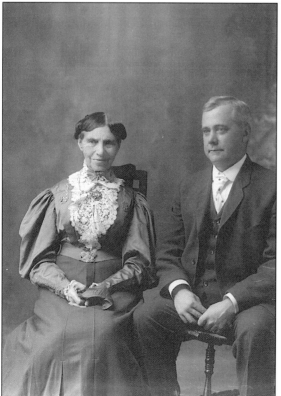

Clara Barton Drew was named after Clara Barton (1821–1912), a Civil War nurse who earned the nickname "Angel of the Battlefield." After the war, Clara Barton was instrumental in the founding of the American Red Cross. In 1909, she visited Ansonia to establish a local chapter, and called upon Clara Barton Drew, who took a number of photographs, including this one of her with her husband John Drew. (David Carver.)

In the days before automobiles were common, and drivers licenses were not needed to drive on public roads, it was possible for a pair of young girls to hitch up a pony to an appropriately sized carriage and take a spin through the neighborhood. Clara Barton Drew took this photograph from the front of her house on New Street, near the intersection with Mott Street.

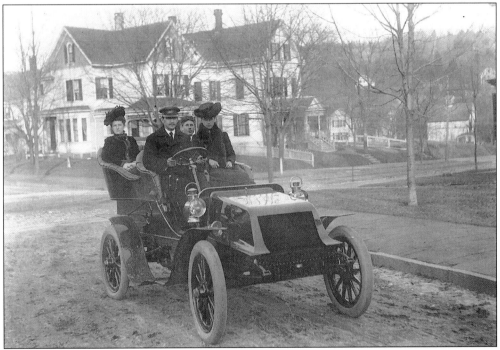

The driver of this brand new automobile interrupts his family's leisurely "motoring" around town to allow Clara Barton Drew to freeze the moment in time at New and Mott Streets. The photograph dates probably to before 1905, because after that time license plates were required on the front and back of all motor vehicles. Drivers of the day wore caps and goggles, due to the lack of windshields, while ladies wore big "duster" hats.

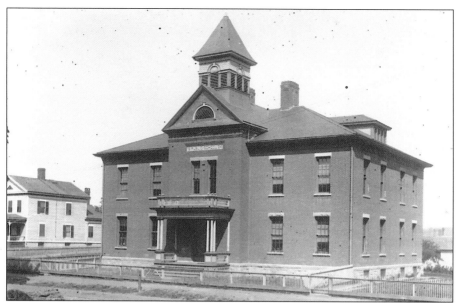

The Elm Street School was built at the top of the road at 2 Elm Street in 1894. The name was later changed to Larkin School, named after its longtime principal Anne E. Larkin. Although the school has since closed, some may recognize the building, as it is still in use. Minus the copula and the porch, the building continues to serve Ansonia today as Police Headquarters.

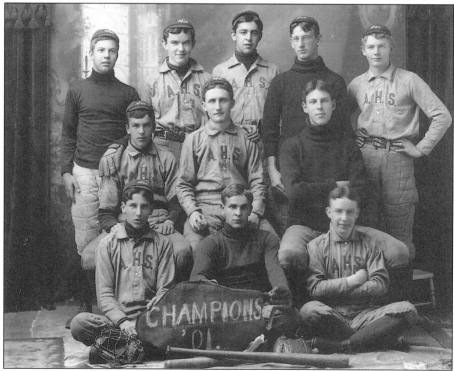

Clara Barton Drew took this photograph of Ansonia High School's baseball team in 1901, in a studio she set up in her New Street home. Like many Ansonia sports teams before and since, the high school's baseball team was the league champion that year.

High school sports were not limited to only male athletes. The Ansonia High School female basketball team posed for Clara Barton Drew in 1904.

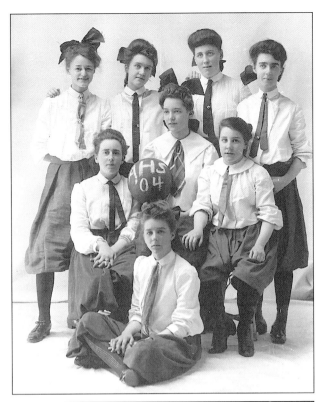

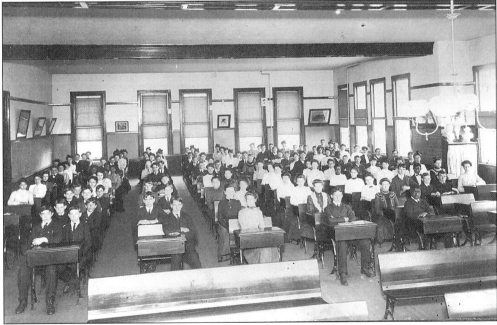

All or some of the girls from the female basketball team in the top picture are in this picture also, taken in the old Ansonia High School's "Main Room," in 1904. Note how some of the students have to "double up" behind desks, including the two boys in the front row left. (Ansonia Library.)

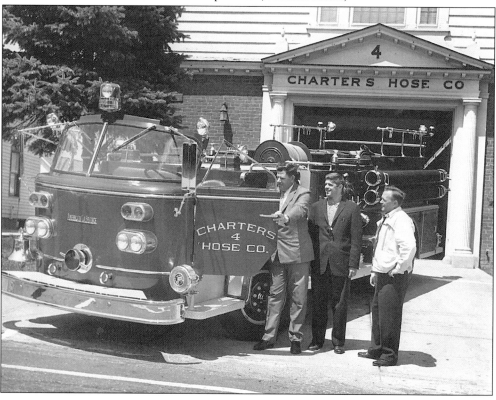

Irish born Stephen Charters was president of a local carpenter's union when he persuaded American Federation of Labor President Samuel Gompers to intervene at a Derby textile factory strike that was tearing the Valley apart in March of 1901. He later went to jail after he was charged with intimidation during a bitter strike at Farrels in July of that year, which nearly caused a riot at the train station. He was elected mayor soon after his release, serving 1901–1905, and 1906–1912.

Fourth Ward residents honored Mayor Charters by taking his name when they formed Charters Hose Company No. 4 in West Ansonia in 1909. Their first and present firehouse, seen here, was completed on Murray and Day Streets in 1924. This May 7, 1961 photograph shows First Lieutenant Michael Kennedy, Captain Raymond McNamara, and Commissioner John Keete taking possession of a new fire engine, which the company has since retained for parades. (Charters Hose.)

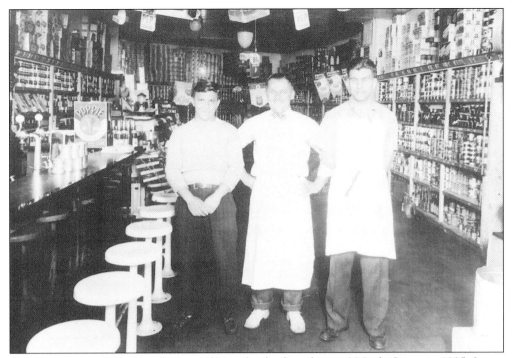

Greek immigrant John Vartelas started Vartelas food market at 6 Maple Street in 1905. It was one of the first stores in Ansonia to make its own ice cream. The price for a double scoop ice cream cone was 5¢ in 1933. His son James Vartelas is pictured on the far right inside the store. Philip Valenti is in the center, while the man on the left is unidentified.

This is an early picture of Vartelas food market on Maple Street, c. 1910. The store continued to operate out of its Maple Street location until the terrible flood of August 1955 destroyed the building. The wagon in front peddled groceries.

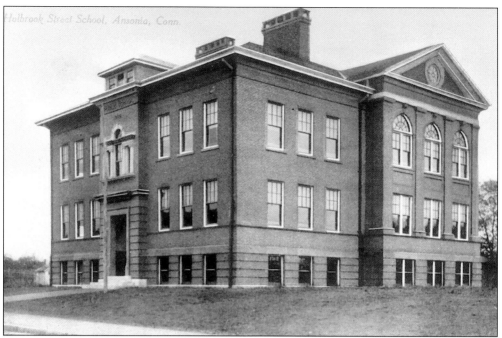

The Holbrook Street School was built in 1905 in West Ansonia. It was later renamed the Peck School to honor one of its former principals, Georgianna Peck. The school remains open to this day, its exterior little changed from when it was first constructed. (David Carver.)

The Garden Street School was completed one year after the Holbrook Street School, in 1906. The school was later renamed Lincoln School, and some time after that again renamed Lincoln-Hayes, after one of its former principals, Mary Hayes. Mary Hayes was daughter of slain police chief John Hayes. Its address has changed to 83 Cottage Street, reflecting where its entrance is today. (Ansonia Library.)

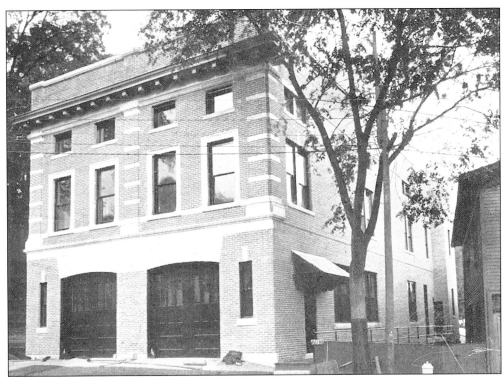

The present firehouse of Eagle Hose, Hook, and Ladder Company No. 6 was dedicated in September 1905, at 1 Main Street. Across the street from Farrels, employees of the plant were allowed to quit work when the fire alarm was sounded. The company's membership roster closely matched Farrel's employment list at times. The eagle mounted atop the firehouse (not visible here) was from the old Blackman building.

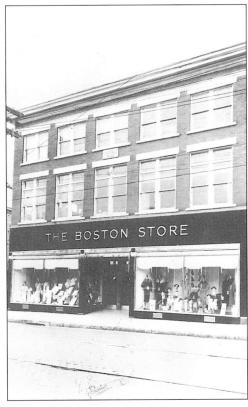

The Murray block was built in 1905 on the corner of Main and Bridge Streets, where the old Boston Store once stood. The store continued to operate out of the new building at the same location, lasting well into the 1930s. The building, at 296 Main Street, housed Arnold's Furniture when it was destroyed in a terrible fire on April 22, 1987. (Ansonia Library.)

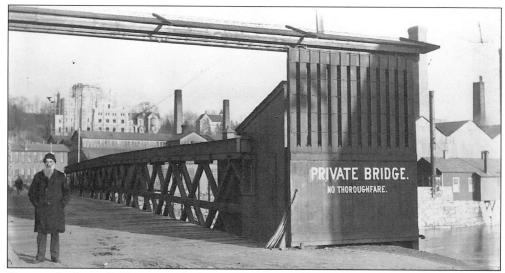

Gate tender James P. Cotter guards the private Brass Mill Bridge off River Street. The bridge, in West Ansonia, leads to the Ansonia Brass and Copper Mill on the east side of the river. Assumption Church is under construction in the background. Ansonia Brass and Copper was a direct descendant from Anson Phelps's old mill. In 1912, it became part of the American Brass Company consortium.

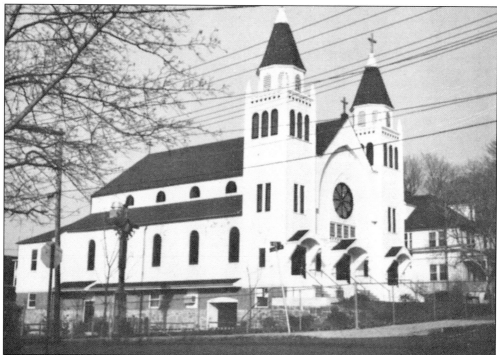

Saint Anthony's of Padua Lithuanian Roman Catholic Church was founded in 1912. The church was built in 1915 at 199 North Main Street, near Sixth Street. Among the organizations the church sponsored in 1935 were the Lithuanian Political Club, dedicated to the study of the American government, and Sviesos Draugija, an educational society. The church continues in this building today. (Ansonia Library.)

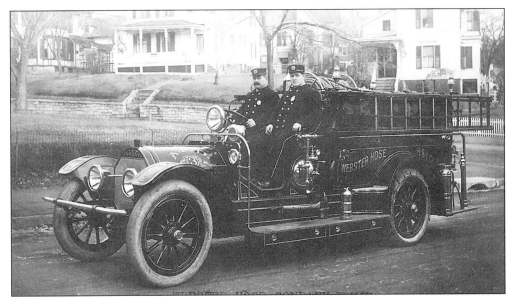

Webster Hose Company purchased its own Bridgeport-built, Locomobile, "auto-chemical" fire engine in 1915. The purchase of the fire engine was kept from the public and most members of the company until the night it arrived in late August. As the news sank in, the *Sentinel* reported "The firemen could no longer contain themselves and the quarters on Platt Street witnessed a crowd of happy mortals." (Ansonia Library.)

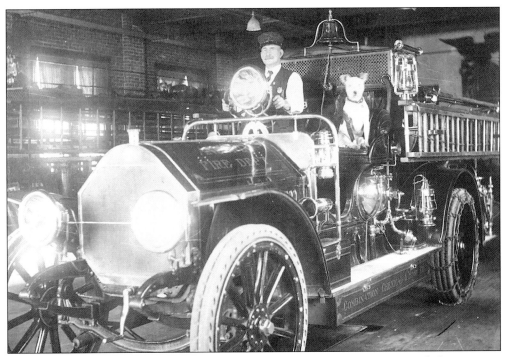

The Eagle Hose Company's William Jarvis and fire company mascot "Spot" are ready for action on the fire company's first motorized fire engine, purchased in 1915. The vehicle was affectionately known as "Old Sparky." The ladder truck, purchased in 1916, is behind the fire engine.

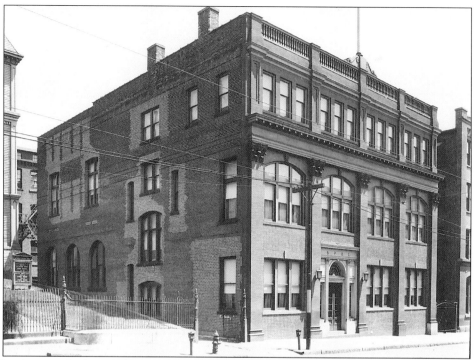

The Ansonia Lodge of Elks was founded in 1912. In 1925, they purchased this building on 51–53 Main Street next to the Methodist Church. The building had formerly housed the YMCA, until that group erected their new building on State Street opposite North Cliff Street. It no longer stands today. Ansonia had 575 Elks in 1935. (Ansonia Library.)

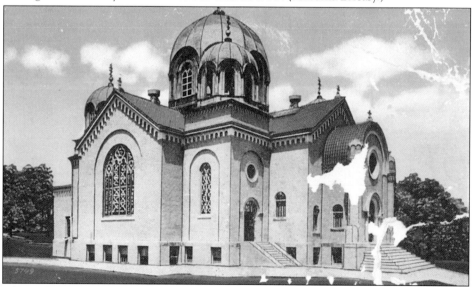

The beautiful St. Peter and St. Paul Ukrainian Greek Catholic Church was completed in 1915 on Clifton Avenue and Short Street. When organized in 1897, it was one of the first Greek Catholic parishes in the United States. The first church was located on May and Bassett Streets. In 1964, the church constructed St. Peter and St. Paul Ukrainian Greek Catholic School on Howard Avenue. (Ansonia Library.)

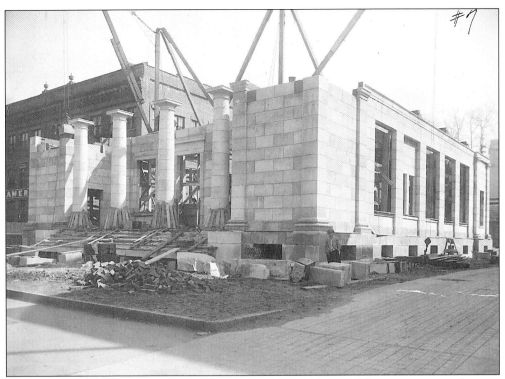

A new federal post office was constructed at 237 Main Street. This picture was taken on May 8, 1914, while the masonry work was still progressing. The now familiar columns have been installed, though the building still lacks a roof. The previous post office was located at 102 Main Street.

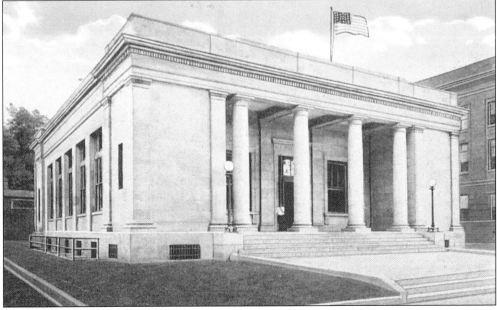

The Ansonia Post Office appears virtually the same today as it did when it was completed. It is now designated as a Connecticut Historical Landmark.

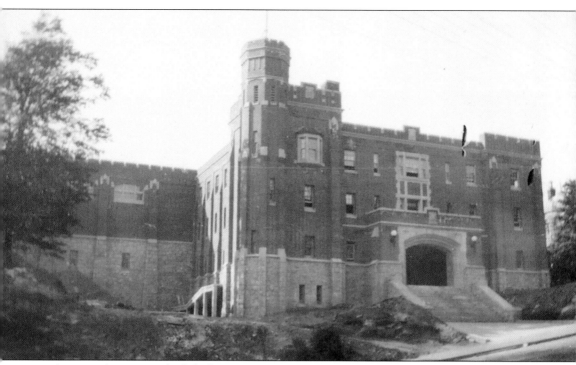

Ansonia Armory was built before WW I at 5 State Street. The first company to be based here was Company M of the 102nd Infantry, Connecticut National Guard (CNG). They were known as "The Colonial Guards" due to their long service history in the Valley area dating to 1685. The company served in a number of colonial conflicts, and later under the American flag in the Revolutionary War, the War of 1812, the Civil War, and World Wars I and II. In 1923, Company I, also of the 102nd Regiment, was formed and assigned to the Ansonia armory as well. Today the Ansonia armory is home to Company D, 102nd Infantry Regiment, CNG, and Service Battery 2 of the 192nd Regiment, CNG.

Six

HOUSES

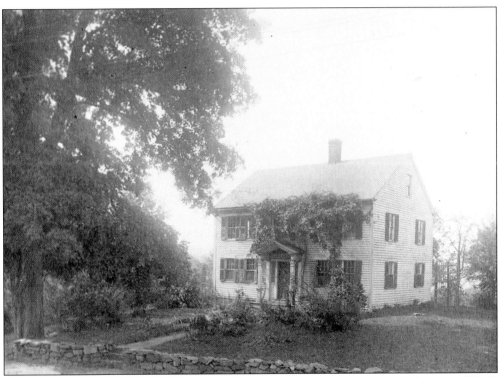

Captain Mordecai Prindle lived at this Federal Style house at 76 Jewett Street built in 1795–6. In 1809, an out-of-season killdeer perched on Mrs. Prindle's window while her husband was on what he said was his last voyage. Superstition said the birds brought premonitions of death, and she predicted her husband was doomed. Neither he nor his crew were ever heard from. The house and land passed into the possession of Reverend Stephen Jewett, Reverend Mansfield's successor, for whom Jewett Street is named. (David Carver.)

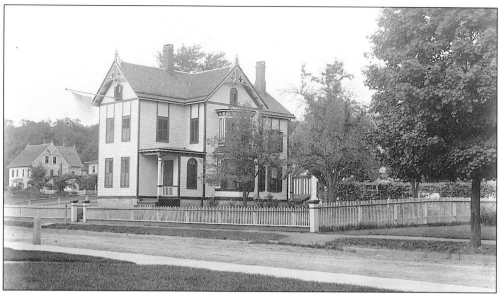

The house at 104 North Cliff Street was built in 1875 by Powe & Stillson for the Barnet family, who moved there in early September of that year. This photograph was taken on July 4, 1907, at 4 p.m. Note the unpaved road, the paved sidewalks, and the hitching post to the left. (David Carver.)

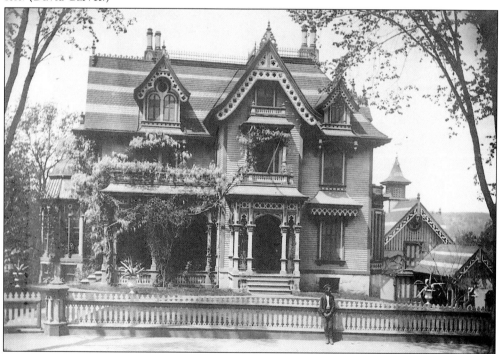

Charles Durand's house was on 34 South Cliff Street. He was for many years president of the S.O.& C. Company. This was one of Ansonia's first "showplace homes" when it was built in 1868. It was of Gothic Revival Architecture popularized by Andrew Jackson Downing and architect Alex J. Davis. The nickname "gingerbread house" evolved from the fancy adornments, which led to the Victorian trend. The house was destroyed by fire in 1936.

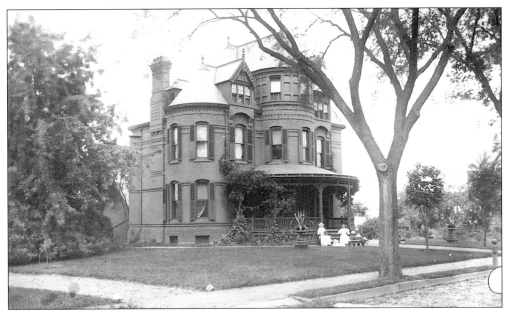

This house was built by Robert and Elizabeth Wood at 91 North Cliff Street. By the time this photograph was taken in 1895, Mr. Wood had passed away. The house is now the Bennett Funeral Parlor. Note the women sitting in front of the porch. The one on the left is holding a fan.

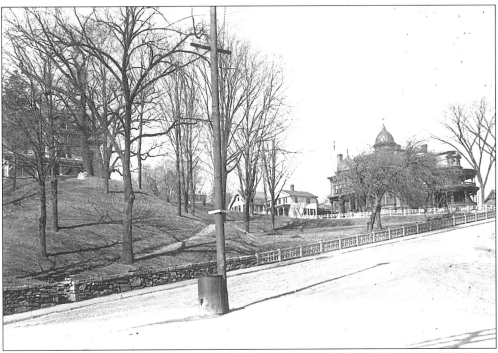

This photograph was taken on State Street hill sometime in the late 19th century. The Farrel house has the dome and rounded porch on the right, while the Slade house is hidden behind trees on the knoll to the left. The armory is now located on the Slade house site. The Farrel house has also been torn down.

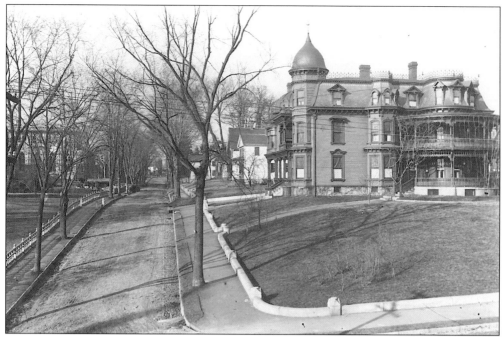

This is a better view of the Farrel house on North Cliff Street. The house was built for Franklin Farrel, Almon's son, and heir to the Farrel Foundry and Machine Company. He died here on January 10, 1912, at age 84. The house was built before 1888, and underwent a number of renovations and additions, which considerably changed the outside appearance of the house, one of the most desirable in Ansonia.

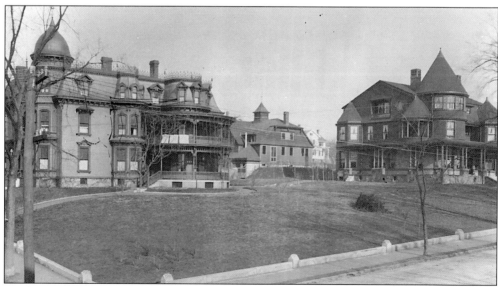

To the right of the Farrel house was the large Charles F. Brooker house, built in the 1890s. Brooker was the first president of the American Brass Company, which included plants in Ansonia, Waterbury, and Torrington. Mr. Brooker and his wife were instrumental in preserving and moving the Rev. Mansfield House on Jewett Street.

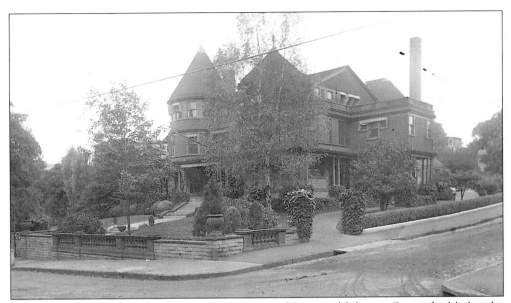

Another view of the Brooker house on the corner of State and Johnson Streets highlights the well manicured and landscaped lawn and the carriage drive on the right. The house has since been razed and two smaller houses now occupy the site. The stonework of the ornate wall and fence still exist today, however.

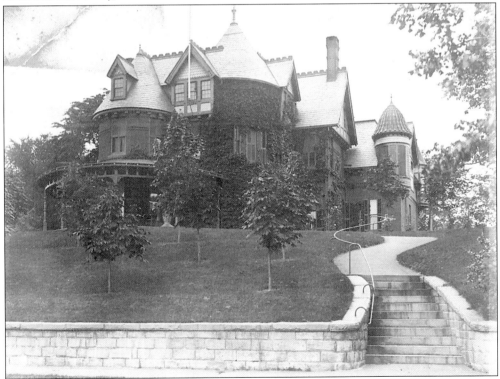

Col. William B. Wooster built this house at 142 Clifton Avenue. He was president of the Derby Gas and Birmingham Water Companies. The house was removed when the Charles Pine Manuel Trade School was built on the site in 1923, a gift to the city from Mr. Pine.

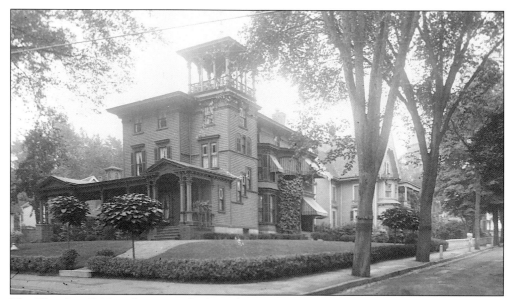

The Theodore P. Terry house was built in the 1860s at 40 State Street at the corner of South Cliff Street. The Terry Block, which still exists on 76–88 Main Street, was erected to house his hardware store. He and his son Frank also sold a wide range of housing supplies. The house has since been torn down, and the site is now a parking lot.

This house on 69 South Cliff Street, next door to the Ansonia Library, was built in the 1870s by Frederick L. Gaylord. He owned the F.L. Gaylord Company, a brass foundry, at 28 Pleasant Street. He was also bookkeeper for Wallace & Sons, and a former postmaster. Note the professional driver at the reigns and an attendant in front of the carriage.

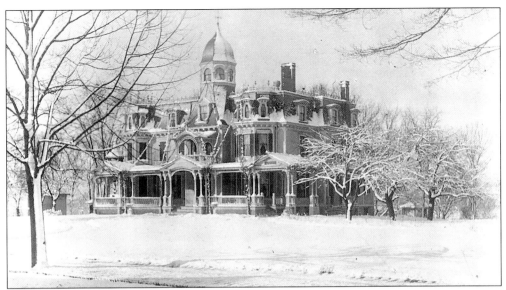

Ansonia's first mayor, Arthur H. Bartholomew, lived in this beautiful mansion at 70 South Cliff Street, right next to Christ Church. He owned the Phelps and Bartholomew Clock Company, which made clocks, watches, and lamps at 285 Main Street. The house was taken down around 1969 to make room for the church's parking lot.

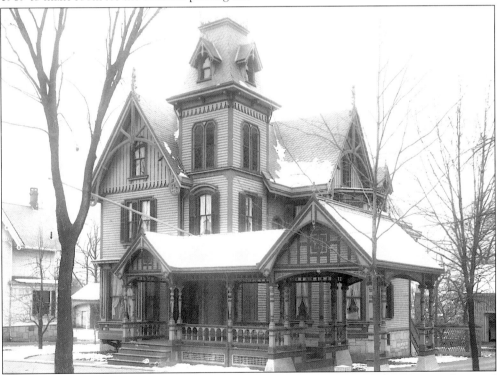

The house at 106 South Cliff Street was built *c.* 1875 by Dana Bartholomew, president and treasurer of the Ansonia Hall Company (the opera house). He was also secretary and treasurer of the Ansonia Water Company, located at 100 Main Street in the Opera House building. The Water Company was formed in 1864.

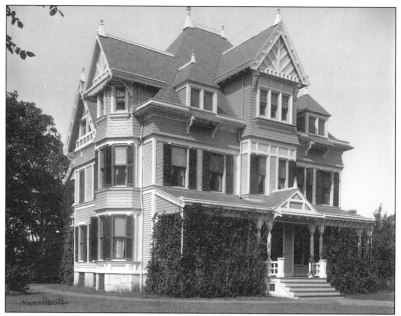

The house at 120 South Cliff Street was built by William O. Wallace, superintendent of Wallace and Sons. William was the son of William Wallace, the electrical pioneer who surprised Ansonia residents when he lit up the city one night while testing his carbon arc lamps atop the tall brass mill chimney in the 1880s.

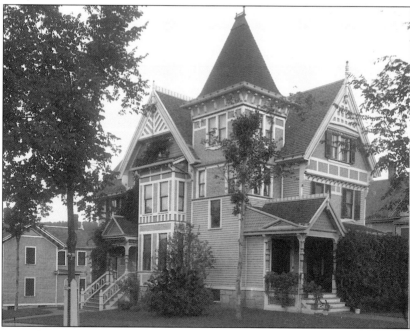

This house at 133 South Cliff Street, at the corner with New Street, was built in the 1880s by Charles Moore, superintendent of the Farrel roll department. The Christian Science Church moved here in late 1934, an account then stating, "The interior decorations are ivory and cream throughout . . . the entries and foyer are covered with a black and cream linoleum." The house is now privately owned.

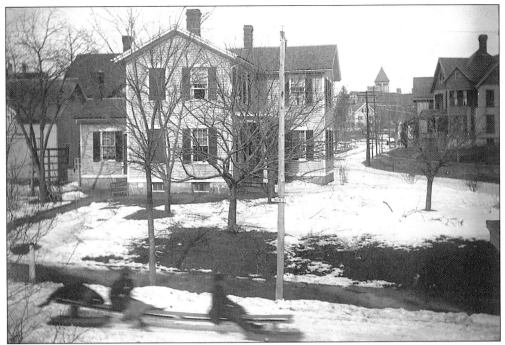

Clara Barton Drew took this picture from the window of her New Street house. The house across the street is 44 Mott Street, the home of Wakeman Mott, who built this first house on the street before 1868. The houses on the right were added in the 1880s. Note the children sleighing down New Street in the foreground and the high school in the background. (David Carver.)

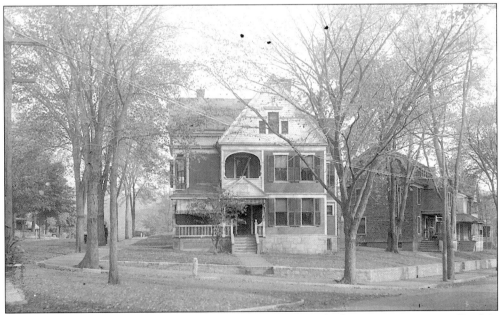

The Frederick Drew House at 2 Mott Street was the home of the first city treasurer, an office Mr. Drew also held in the old borough. He continued to serve in that position, with the exception of a few years, all the way into the 1930s. (David Carver.)

A postman pauses at the intersection of New and Mott Street to be photographed by Clara Barton Drew, about 1910. Behind him is the Drew house at 26 New Street, with 22 New Street to the right of it. The houses were built in the 1870s. Ansonia's first post office opened very early in its history, in 1846.

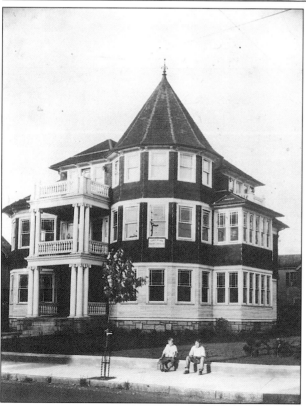

This house is typical of those built in Ansonia neighborhoods in the late 19th and early 20th centuries. This one at 282 Wakelee Avenue was built in 1927 for John and Amelia Mackowski by Ludwig Oliwa. This photo was taken not long after the house was completed. The contractor's sign still hangs from the second floor.

Seven

ERA OF THE
WORLD WARS

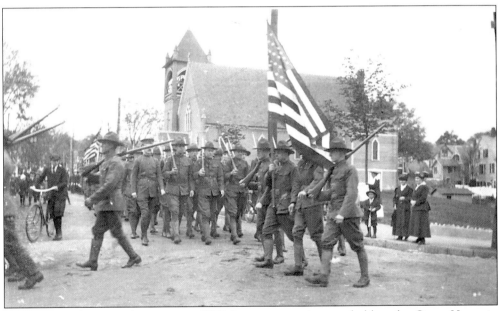

Anticipating the nation's entry into WW I, a mass meeting was held at the Opera House in March of 1917. The purpose of the meeting was to organize the Home Guards, a local defense group, should the National Guard at the Armory be called to active duty. The Home Guard marches around the corner past the Immanuel Episcopal Church onto Howard Avenue in this image.

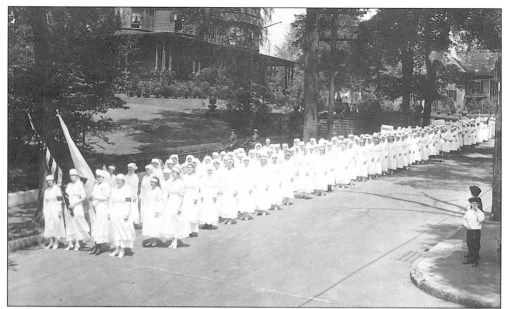

A seemingly endless procession of Ansonia women who answered Clara Barton's call in 1909 and volunteered for Red Cross service during WW I marches past the Farrel home on May 18, 1918. This is just one of the many examples of Ansonia residents who enthusiastically supported the United States during WW I, known then as the Great War. (Ansonia Library.)

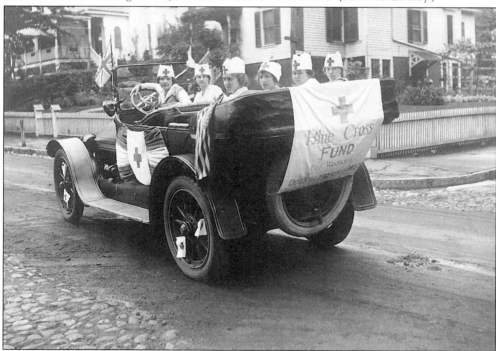

A car adorned with American flags and flags of the WW I allies pauses to be photographed at the corner of Mott and Garden Streets. Red Cross volunteers Bernice Ballon, Mrs. Ballon, Marian Keller, Marjorie Nurbeth, Elizabeth Manville, and Elsie Woodruff are in the car. Ansonia residents raised well over $64,000 for the Red Cross in 1917.

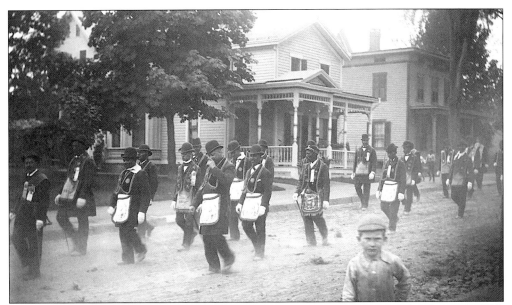

Members of the James Henry Wilkens Lodge No. 9, F&AM, PHA, parades during WW I. This African-American Masonic lodge was formed in Ansonia in 1893. They used to meet at Forester's Hall on 208 Main Street. America entered WW I on April 6, 1917.

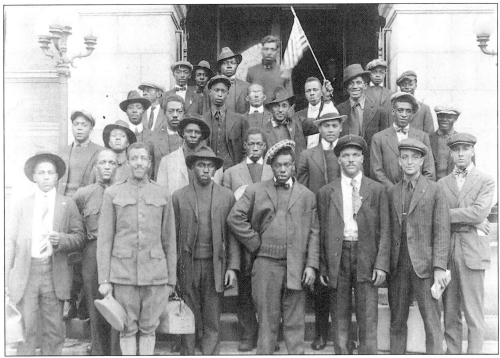

African-American residents who had been drafted and were awaiting the call to duty were entertained by the Frances Harper Club at a banquet at city hall on February 20, 1918. Ansonia residents took a very active interest in the war, even before word reached home that the 102nd Regiment had reached the Western Front. Two companies from the 102nd were based at the Ansonia armory.

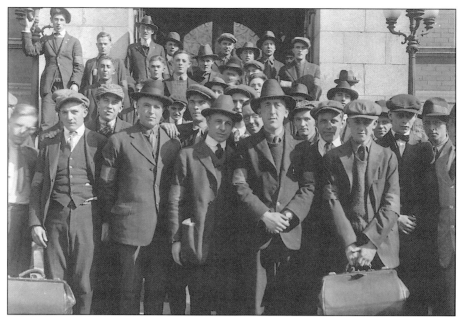

This photograph of new Ansonia soldiers preparing to leave for boot camp at Fort Devens in Ayer, Massachusetts, was taken in front of city hall on October 23, 1918. By this time, the Spanish Influenza epidemic had gripped the eastern United States. Ninety-seven of the 110 deaths in the city that month were from the influenza.

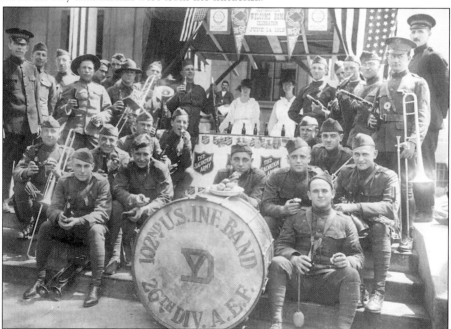

The 102nd Infantry Regiment of the Connecticut National Guard was activated as part of the famous 26th Infantry "Yankee" Division, American Expeditionary Forces, during WW I. The 102nd Infantry band played during Ansonia's official Welcome Home Celebration on June 14, 1919. The man in the upper left corner is Captain George Brown of the Salvation Army. He sponsored a fund-raiser in Ansonia that sent two ambulances to the Western Front.

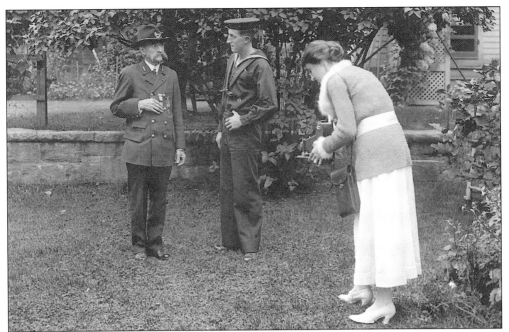

Clara Barton Drew captured this priceless image during a reception in her backyard on 26 New Street in June of 1919. An old veteran from the Civil War, still proudly wearing his Grand Army of the Republic uniform, converses with a young, bespectacled sailor just back from WW I, which had ended less than a year before.

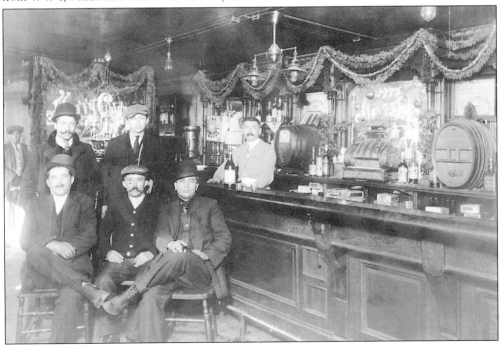

Polish immigrant John Mackowski (whose home is pictured earlier in this book) was the proprietor of the Coney Island Restaurant downtown. This photograph was taken in 1920. Christmas and New Year decorations are hanging behind the bar.

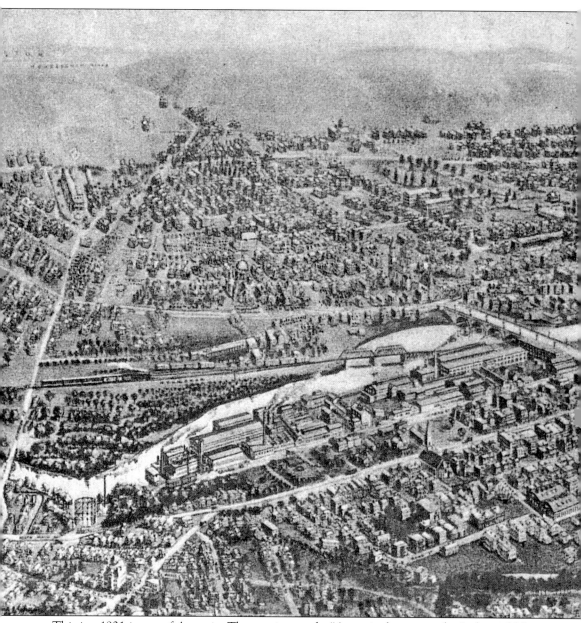

This is a 1921 image of Ansonia. The caption reads, "Ansonia, known as the Industrial Heart of the Naugatuck Valley, is situated at the confluence of the Housatonic and Naugatuck Rivers, at the foot of the Berkshire Hills. With a population of about 18,000, it has acquired a fine record of achievement in Manufacturing, Mercantile Buildings, and Public Utilities. It is on the Naugatuck Division of the N.Y., New Haven, and Hartford Railroad, where all through trains

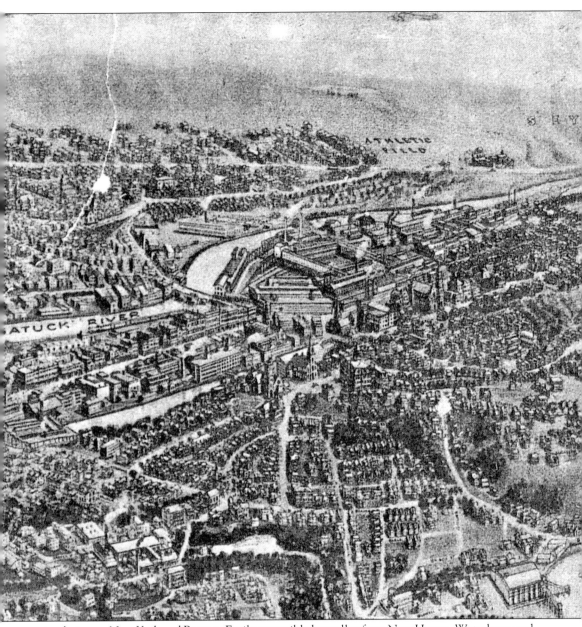

stop between New York and Boston. Easily accessible by trolley from New Haven, Waterbury, and Bridgeport, it has gas, electric light and power, telephone system, fire department with electric fire alarm system, adequate trolley facilities, superior and well supported police and an abundant supply of pure water. Its educational advantages are of the highest order and excellence and the social, fraternal, religious, and charitable organizations are active and fully represented."

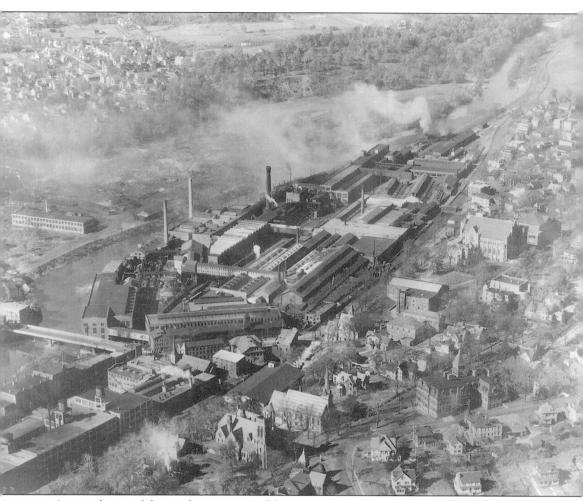

An aerial view of the northern portion of downtown Ansonia was taken c. 1925. The Ansonia canal begins by the millpond on the upper right corner, and winds all the way down behind the buildings on the lower left. Main Street lies in front of the buildings in the lower left corner. The Maple Street bridge crosses into West Ansonia, with the Vartelas block on its right. The twin spires of the Methodist Church are to the right of the bridge. Ansonia Library is on the bottom, in the shadow of Christ Church and the Congregational Church on South Cliff Street. The large brick building right of the churches is the Ansonia High School. The armory is above the school on State Street. The church above the armory is the Church of the Assumption, with its school right next to it. The Farrel and Brooker homes are across State Street from the armory, to its right. The large square building just next to the Farrel house is the Masonic Temple. The Farrel factory complex dominates the center of the picture, as smoke from its stacks and trains partially obscures West Ansonia.

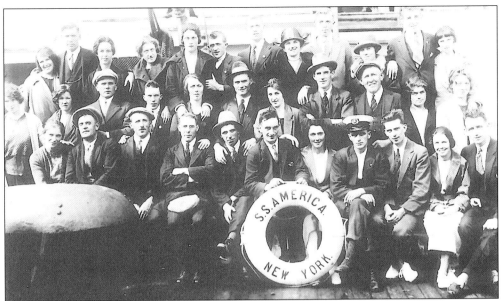

Immigrants continued to pour into Ansonia after WW II, such as those who posed on the steamship *America* on her way to Ellis Island in 1921. This voyage brought Teofii Halicki (second row, third from left) to America. He joined the Polish community in Ansonia. Fully one-third of Ansonia residents was foreign born in 1920. The groups, from largest to smallest, were Polish, Russian, Irish, Austro-Hungarian nationalities, English, and Lithuanian.

Warsaw Park was founded in 1933 on Pulaski Highway by Rev. Joseph Janoswski of St. Joseph's Roman Catholic Church. Thirty acres of land were purchased from the Ansonia Water Company. The funds for the purchase were a gift from St. Stanislaus Church in New Haven. Saint Joseph's was founded in 1925. Its church, which began construction in 1926, and school are on Jewett Street.

In 1921, the Colburn house on 115 Howard Avenue was purchased by the City of Ansonia and converted into a four-room schoolhouse. The house was razed by 1935, with the intention of putting a new high school there. The old high school, which burned in 1939, was considered one of the most overcrowded in the Naugatuck Valley, lacking an auditorium, gym, and lunchroom. The new school was completed in 1937.

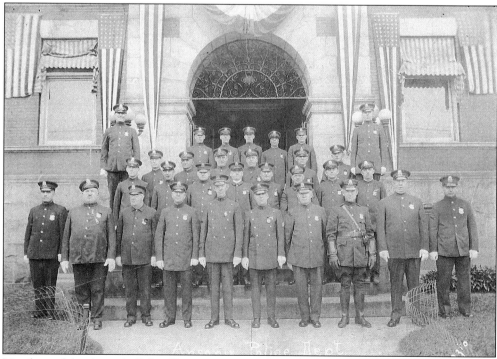

Members of the Ansonia Police Department pose for a photograph on Memorial Day in 1930. The officer third from right in front with the sash was a motorcycle patrolman. John Mahoney, the tall man fifth from left in the front row, was chief from 1930 to 1952. Police headquarters, at the time, was in city hall. (Ansonia Police Department.)

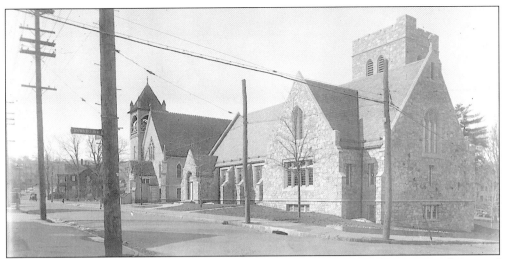

The new Immanuel Episcopal Church, seen here at 6 Church Street at the corner with Howard Avenue, was completed in the mid-1930s. The Church has since merged with the Church of St. James in Derby, which is now known as Immanuel St. James. The conservative Episcopal Church of the Resurrection has occupied the old church since December 1996. The old church, behind it, was replaced by a parking lot. (David Carver.)

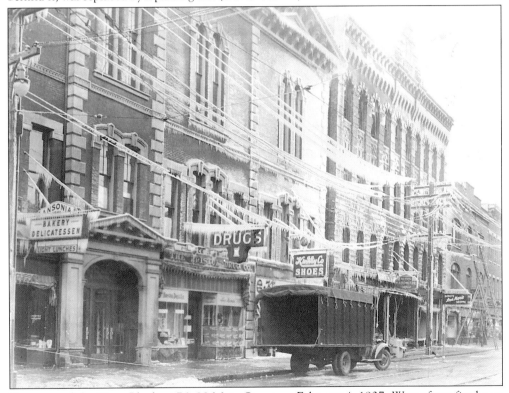

Fire ravaged the Terry Block at 76–88 Main Street on February 4, 1937. Water from fire hoses froze on contact with hard surfaces, turning the street and nearby buildings, like the Ansonia Opera House in the left foreground, into an icy wonderland. The Terry Building was repaired and remodeled, and still exists on Main Street to this day. (Ansonia Library.)

Ansonia residents ardently supported our troops in WW II with the same zeal and vigor they displayed in WW I. The Catholic Daughters of America, Court Seville, from Assumption Church sponsored Ansonia's fifth war bond drive, around 1943. Pictured here in front of city hall are, from left to right, the following: Eleanor Bruenig, Alice Carle, Elizabeth Finnucan, Father William Kennedy, Anna McCarthy, and Mayor Andrew Nolan.

On February 24, 1941, before America's entry into the war, the 102nd Infantry Regiment, containing the two companies from the Ansonia armory, were activated and made a part of the 43rd Infantry Division. Many other Ansonia residents served in other units, such as Joseph Borcherding and George Bush Clark of the 4189 Quartermaster Corps, pictured here in 1944 in Hollandia, New Guinea.

As a young Marine Corps lieutenant, Ansonia native Samuel Jaskilka survived the sinking of the aircraft carrier *Princeton*. He saw more combat in the Korean War, fighting the Chinese at the Chosun Reservoir. Rising to the rank of brigadier general, he was a top strategy planner in Vietnam. In his years of service, he won two Silver Stars, a Bronze Star, and a Distinguished Service Medal. The Valley portion of Route 8 is named for Ansonia's famous son.

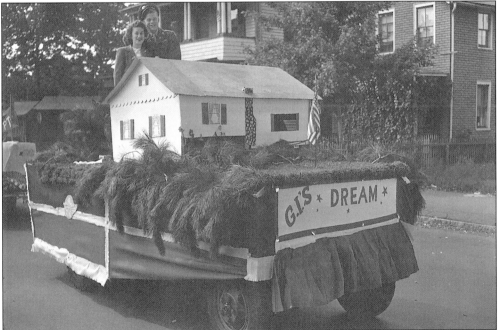

Troops trickled home after WW II. Thousands of Ansonia citizens served in the armed forces during WW II, and over 60 of them died during that time. By September of 1946, enough had returned for the city to hold a Welcome Home parade for local soldiers. This float, entitled "G.I.'s Dream," said it all. Whole new suburbs such as the Hilltop section east of downtown were constructed in Ansonia not long after the war.

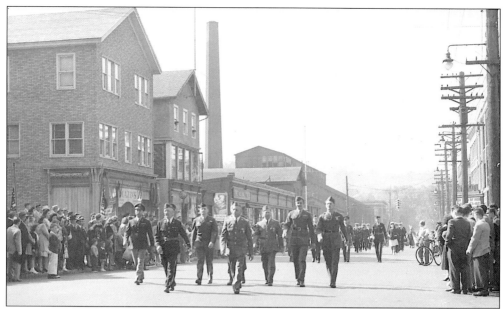

The Welcome Home parade winds its way down Main Street. Pictured in front are, from left to right, one unknown person, Bert Springer, Joseph Doyle (later mayor of Ansonia), Mo Dennerstein, John Schumacher, and Walt Stakawicz.

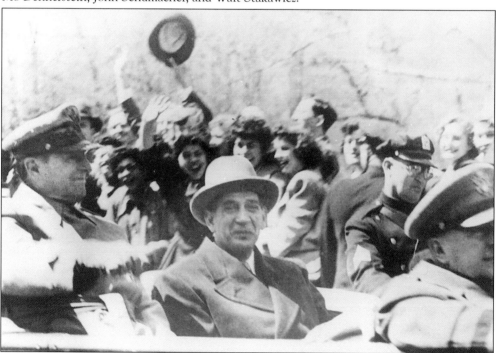

Vincent R. Impellitteri was born in 1900 in Isnelo, Italy. His family settled in Ansonia when he was young. He entered the Navy after he graduated Ansonia High School in 1917. After the war, he lived in New York City, where he became an attorney. In 1950, he became the only mayor in New York City elected on an independent ticket. He is seen here with Gen. Douglas MacArthur in 1952.

Eight

A TRIBUTE TO FARRELS

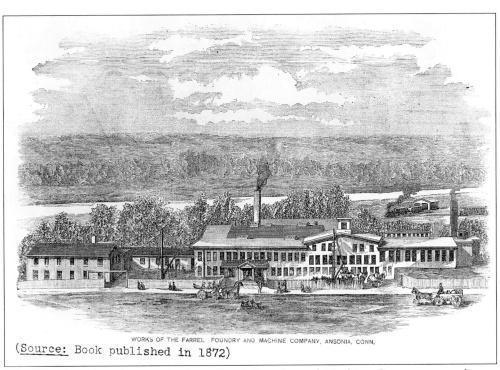

WORKS OF THE FARREL FOUNDRY AND MACHINE COMPANY, ANSONIA, CONN.

(Source: Book published in 1872)

By 1872, when this photograph of the Farrel Foundry and Machine Company was taken, a branch plant had been opened in Waterbury. In 1880, that branch would become Waterbury Farrel Foundry & Machine Company. The company began making sugar mills for the cane sugar industry in 1870.

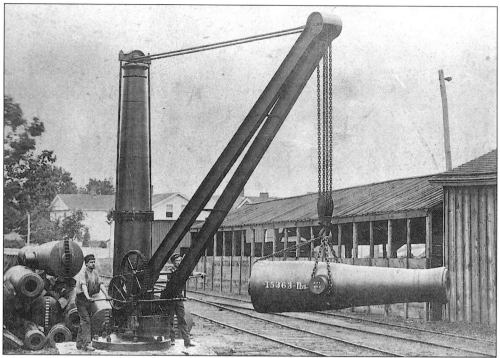

Those Farrel employees who were not serving in the armed forces during the Civil War found themselves manufacturing some of the arms and ordinance that would supply troops fighting to preserve the Union. Here, a cannon weighing over 7 1/2 tons is hoisted near the siding of the foundry. Note the completely manual-driven gears on the crane.

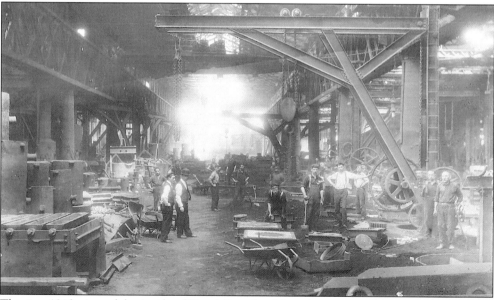

This is a 1913 view of the inside of Farrel Foundry. Note the intense glow in the background from the blast furnaces and the dirt floor. For over a century and a half, Farrel Foundry has been a major employer in Ansonia. Some families have worked there for generations. The factory dates almost as far back as the town's first settlement.

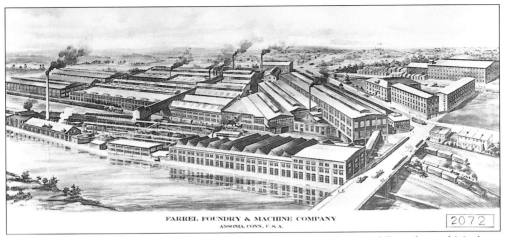

The Maple Street bridge is in the foreground of this image of the Farrel Foundry and Machine Company, as it appeared during WW I. During that war, the company produced gun carriages and shell presses. The company also produced castings for engines that were constructed for over 100 U.S. Navy "four stacker" destroyers.

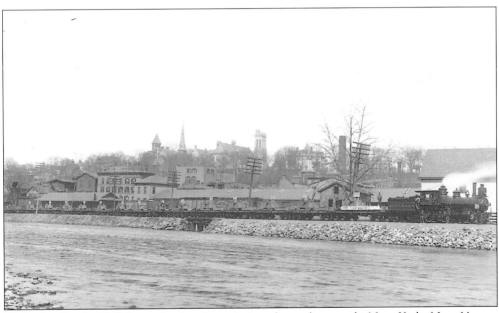

With the South Cliff Street landmarks pointing skyward, an early New York, New Haven, and Hartford steam locomotive train pulls out of the Ansonia freight yard. It pulls a seemingly endless procession of flatcars bearing the biggest mill Farrel had ever produced up to that time, bound for Latin America.

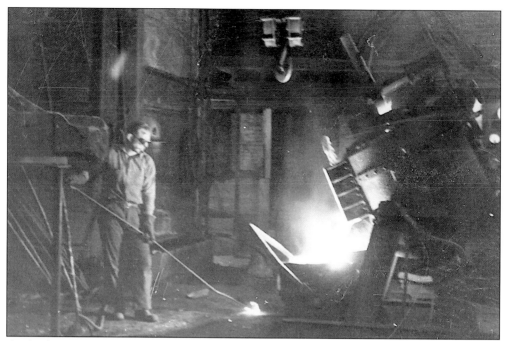

At the heart of Farrel Foundry were countless employees who over the years toiled over the furnaces that molded molten metal into heavy machinery products. This picture was taken in 1936 by Franklin Farrel III, Almon's great-grandson.

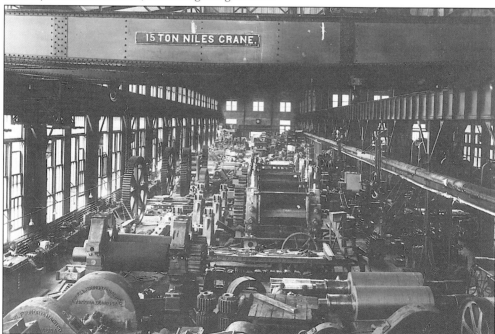

In 1927, Farrel Foundry and Machine Company merged with one of the few companies in the Naugatuck Valley that was older than it, the Birmingham Iron Foundry in Derby, founded in 1836. Renamed Farrel-Birmingham, both plants were kept open until the Derby plant closed in 1997. Farrel-Birmingham's Ansonia plant remains open in 1999.

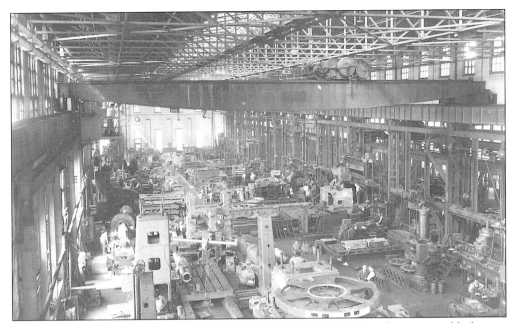

Farrel-Birmingham produced propulsion gears for warships and other shipping, molds for gun barrels, and hydraulic presses for airplane parts in WW II. No doubt more than one homesick sailor derived comfort from reading Farrel's logo and "Ansonia, Conn." on machinery in ships' engineering sections. The 15-ton Niles crane, which ran on tracks to move heavy material, rests on tracks over the shop floor.

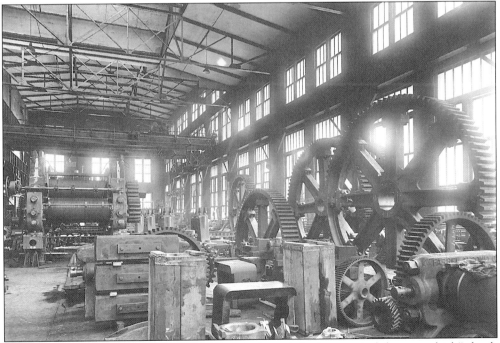

Huge gears were manufactured at Farrel-Birmingham, bringing to mind the proverbial "wheels of American industry" as they await delivery on the shop floor. This surely will be a job for the Niles crane, in the background to the left.

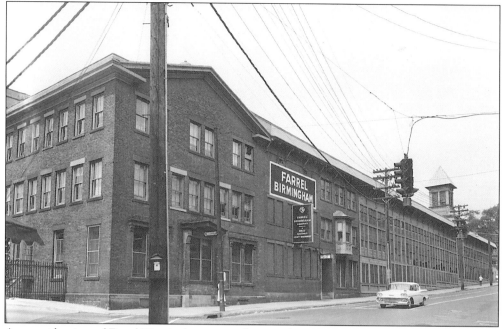

An outside view of Farrel Birmingham was taken on August 24, 1959, on the corner of Main and Maple Streets. The older portion up Main Street has changed in appearance, including having its old belltower removed, but it is still the same building.

The old factory bell was removed from the dismantled bell tower on November 14, 1964. The belltower was used to call employees to work, back in the days when clocks and wristwatches were not as common as they are today. The bell was later installed nearby as a memorial to Ansonia firefighters.

Nine

THE FLOODS OF 1955

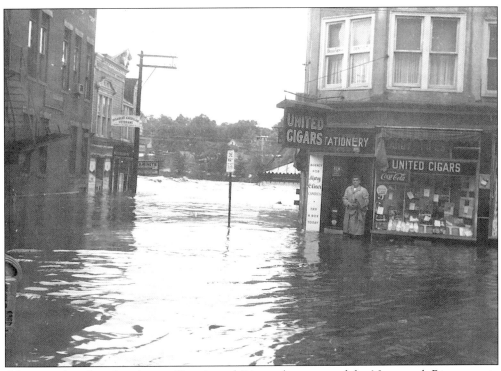

After twin hits from hurricanes Connie and Diane, the waters of the Naugatuck River rose to an unprecedented level the night of August 19, 1955. Norman Shaftel appears to be an island of calm amidst calamity in this picture, as he stands in the doorway of his ruined United Cigar Shop at 164 Main Street. (Ansonia Library.)

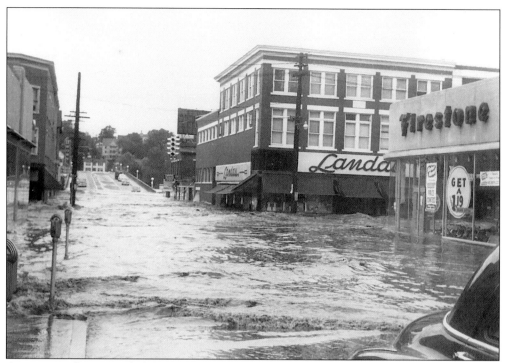

Ansonia residents were helpless to do much but get to high ground and watch as water roared down Main Street and other low lying areas of town. This photo shows the corner of Bridge and Main Streets. The Maple Street, Division Street, and American Brass Company bridges were destroyed. The Bridge Street bridge was impassable during the flood, though not outright destroyed. It was replaced not long after the flood. (Ansonia Library.)

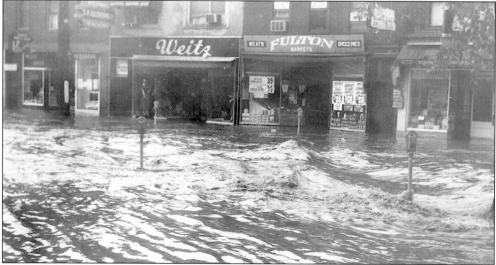

Churning water washes past Weitz Dresses at 252 Main Street and Fulton Market at 246. Fulton Market also had stores in Shelton and Seymour. Many saw their livelihoods set back or destroyed by the relentless floodwaters. One business which not only recovered but is still open in the same location today as it was in 1955 is Vonetes Brothers ice cream and confectionery store, at 242 Main Street, on the right. (Ansonia Library.)

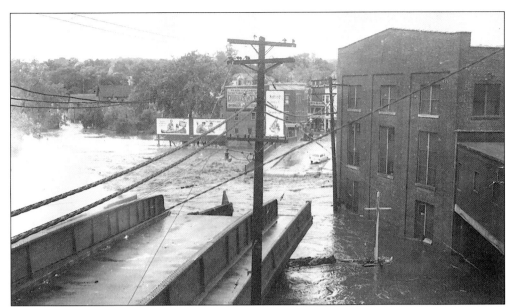

Just after noon, on August 19, the private brass company bridge was torn from its abutments and began a destructive journey downstream. It smashed into the Maple Street bridge just as Peter Waniga of Peter's Package Store on 4 Maple Street was making a return trip from evacuating downtown. Leaping from his car, he made it to shore just as the bridge fully collapsed, taking his new 1955 Ford station wagon with it.

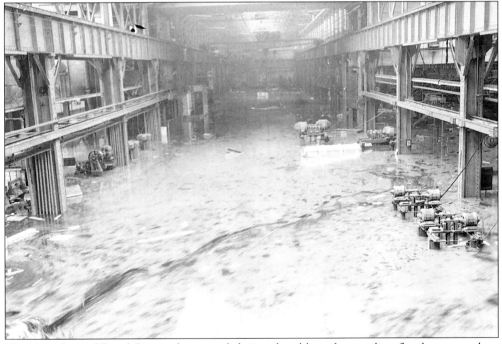

The shop floor of Farrel-Birmingham was left in a shambles, after swirling floodwaters as deep as 10 1/2 feet submerged products and machinery. Even after the waters subsided, huge amounts of mud were left in its wake. Farrel-Birmingham recovered from the calamity, and resumed pre-flood levels of production.

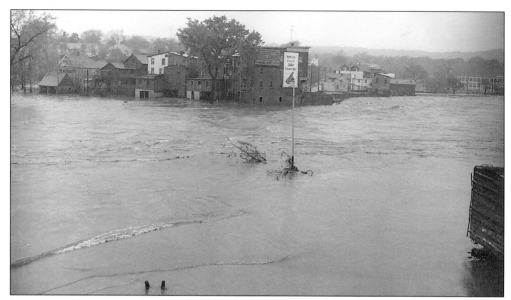

Low areas of West Ansonia were also heavily damaged. Power lines draped over the angry river are the only sign left that the Maple Street bridge once crossed on the right. Maple Street, to the right of the building with the white *7-Up* sign, abruptly ended at the river. The building across the street that appears to be leaning into the river is the Vartelas block. (Ansonia Library.)

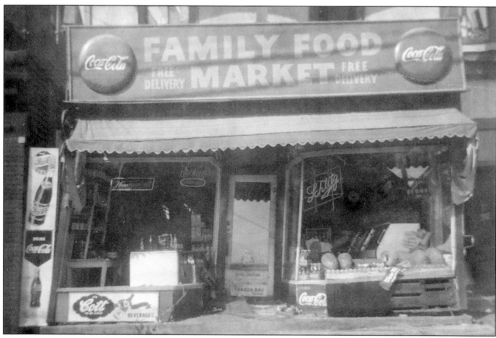

The Vartelas block at 6 Maple Street, which housed the Family Food Market, Peter Waniga's package store, and eight apartments, was destroyed. It was left with smashed plate glass windows, its roof leaning toward the river, and missing some walls. Located close to the river, the brass company bridge swept into the building at the same time it destroyed the Maple Street bridge. Vartelas Park was dedicated here on August 28, 1987.

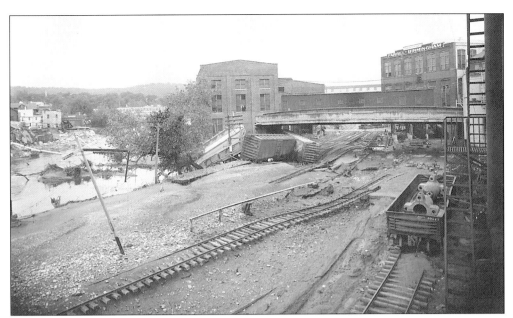

Ansonia is shown here shortly after the floodwaters of August 1955 subsided. Watermarks on the remaining portion of the Maple Street bridge bear evidence of the water's depth and ferocity. Another part of the span bows to the river that destroyed it to the left. The railyard was destroyed, box cars flung about like toys. (Ansonia Library.)

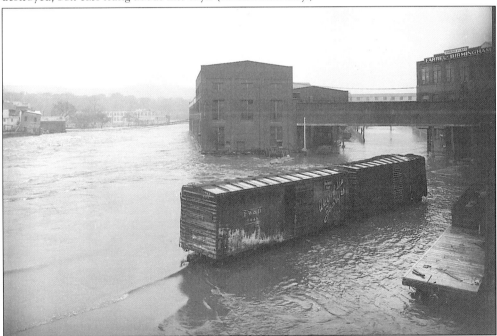

Recovery efforts were hampered when a second major flood struck the area on October 15, 1955. A temporary bridge thrown across the Naugatuck to replace those destroyed in the August flood was itself swept away. This photo shows the freight yard again inundated with water. The two boxcars are the same ones shown derailed in the top photograph. They still bear the marks from the earlier flood. (Ansonia Library.)

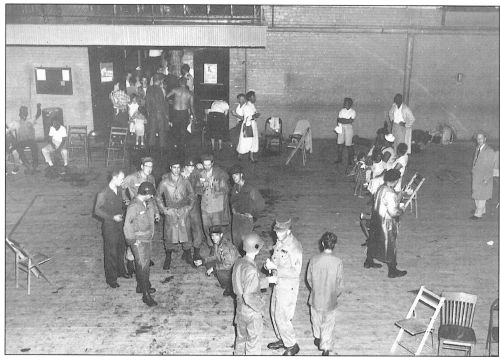

The State Street armory was pressed into service as an evacuation center, medical aid station, inoculation clinic, and field kitchen. The local National Guard units were activated and pressed into service to aid recovery efforts and prevent looting. Parts of town fell under martial law. Flying over the area on Air Force I, President Dwight D. Eisenhower declared the area a Federal Disaster Area. (Ansonia Library.)

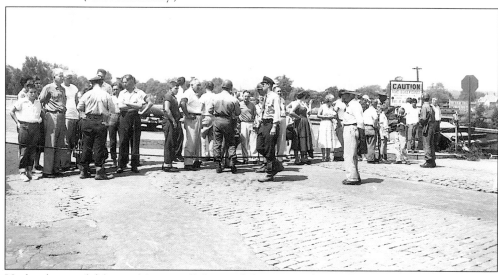

Under the watchful eye of Ansonia Police and the National Guard, residents line up on Bridge Street immediately after the August flood for passes into the stricken area. For many, it was their first chance to assess the damage left by the floodwaters. Mayor Joseph Doyle was a leader in obtaining assistance for the valley, returning from Washington with promises of $20 million for flood control assistance. (Ansonia Library.)

EPILOGUE

The Army Corps of Engineers erected a temporary "Bailey Bridge" to allow Ansonia residents to cross the river while the destroyed bridges were replaced. Located south of Maple Street, this bridge was used from 1955 until 1960. The photograph was taken in 1958.

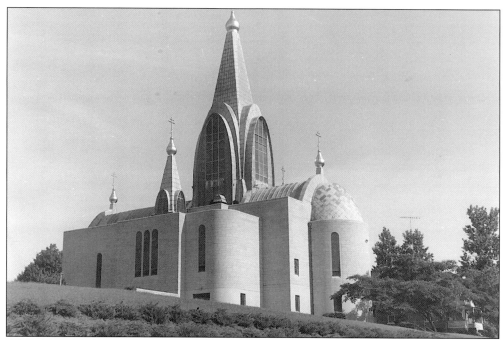

After their old church was gutted in a 1954 fire, the Three Saints Russian Orthodox Church dedicated this new edifice on Howard Avenue in 1956. The gold spire reaches over 120 feet into the air. The bells from the old church, donated by Czar Nicholas II, were put into the new one. It has been called one of the most beautiful Orthodox churches in the eastern United States.

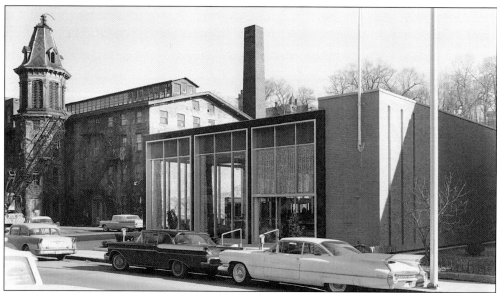

After the flood, the Ansonia Savings Bank built one of the first new structures on Main Street for quite some time to follow. The new office, at 211 Main Street, seen here on the right, was located next to the old Ansonia Clock Factory, which was torn down a few years later. Kingston Drive now runs where the factory was. The photograph was taken January 29, 1962. First Union now operates out of the bank.

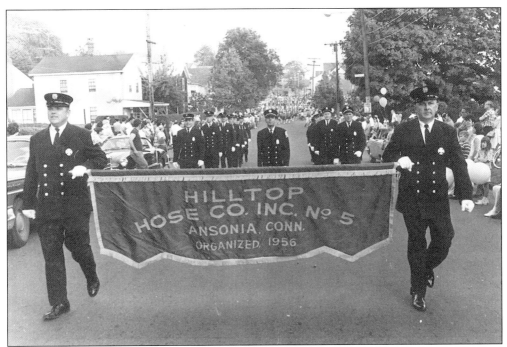

After WW II, the Hilltop area of Ansonia began to expand with suburbs. Between 1940 and 1960, the number of taxable dwellings increased to almost 2,000. The Flood also added to the suburban boom, with 311 building permits granted in 1957 alone. Hilltop Hose Company No. 5 was organized in 1956 to protect the new suburb. Their firehouse was built that same year on Pulaski Highway. It was enlarged in 1971. (Hilltop Hose Company.)

Now the Ansonia Middle School, the John J. Prendergast School, pictured here, was built in 1960 at 59 Finney Street. The Mead School was built in 1967 at 75 Ford Street, replacing the 1925 Mead School at 59 Factory Street. Emmett O'Brien Regional Vocational Technical high school, which serves the entire Valley, opened a year later on Prindle Avenue. The new Ansonia High School opened at 20 Pulaski Highway in the autumn of 1999, making four schools in the Hilltop area.

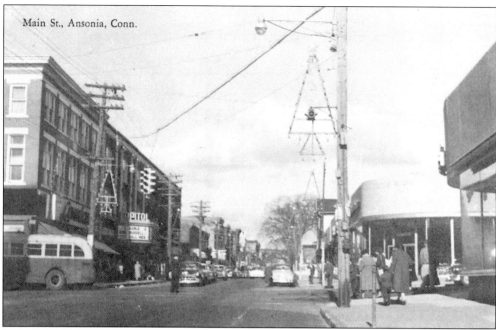

Main St., Ansonia, Conn.

This is how Main and Bridge Streets looked at Christmastime during the 1950s. Ansonia's light display had to be curtailed during WW II for fear of air raids, but resumed after the war. Landaus now occupies the store once occupied by the Boston Store. The marquee of the Capitol Theater can be seen behind it. (Ansonia Library.)

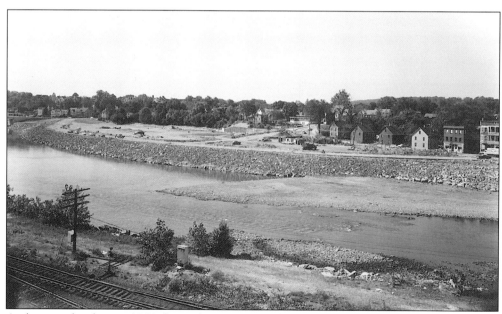

A photograph taken in 1961 shows the progress of the Broad Street Renewal Project, derived from federal funds. Much of the ruined and old housing has been cleared along Broad Street. Federal money built the Olson Drive apartment complex, the West Side Shopping Center, and the West Side light industries, along with a municipal parking lot.

The progress of the new retaining wall along West Main Street is seen in this photograph taken on December 12, 1971. Now completed, the massive flood control project is meant to shield Ansonia from the devastating floods that caused so much damage in 1955.

This view of the flood control project was taken on West Main Street on April 2, 1971, north of the new Bridge Street bridge, and shows the lengths taken to prevent another calamity like that of 1955. The floodwall stretches around the bend of the river, as far as the eye can see. The direction is to the south.

The Main Street area south of Bridge Street was devastated by the flood. Most of the buildings there had to be torn down. The new Ansonia Mall was built on the site of the old neighborhoods. It was meant to revive commercial business downtown. The mall was unable to compete with larger, newer shopping malls in the suburbs. It was razed in 1997 and replaced with a shopping center.

Holy Rosary Roman Catholic Church was established by Ansonia's Italian population in 1909. Their church was the former Assumption Church on 451 Main Street. The entire neighborhood of the church was heavily damaged by the Flood, and razed to make way for development. The new Holy Rosary Church, seen here, is on the new Father Salemi Drive, not far from its old site.

The Ansonia Nature Center was dedicated to the citizens of Ansonia on November 19, 1977, on land that was at one time designated for a municipal golf course. The Center's mission is "to instill a reverence for all life and promote a lasting environmental stewardship of the earth." Containing sports fields, a playground, pavilions, a nature building (pictured here,) and acres upon acres of unspoiled wilderness, the Center is a local treasure. (Ansonia Library.)

The fallen leaves on Nolan Field at Ansonia High School on Wakelee Avenue signal it must be time for another football season. To say Ansonia is passionate about its football team is an understatement, and the Chargers have played and won countless games and championships on this and visiting fields. Although the High School is moving to Hilltop, it will still be the Charger's home field in the immediate future. (Ansonia Library.)

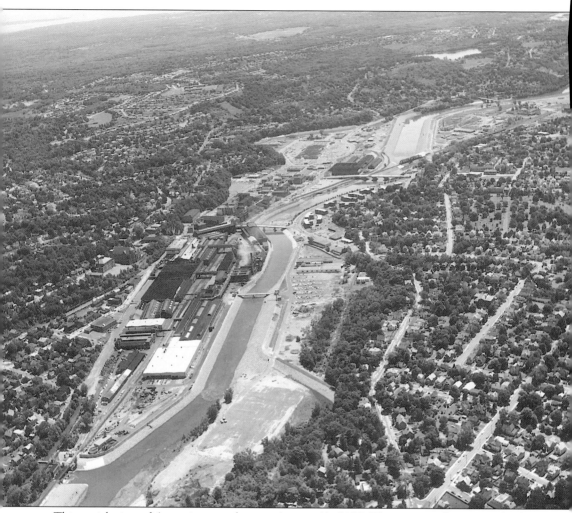

This aerial view of Ansonia was taken on August 11, 1972. The massive degree to which the Army Corps of Engineers installed flood protection is evident along the entire length of the Naugatuck river. All of the bridges have been fully restored and improved. Now filled in, the canal stops just below Farrels in the bottom left corner of the picture. Many of the old landmarks can be seen, as well as new developments. The Olson Drive housing complex is on the west side between the Maple and Bridge Street Bridges. The large building surrounded by parking above Main Street where a residential neighborhood once stood is the old Ansonia Mall. Hershey Metals is on Ansonia's side of Division Street on the upper right where Super Stop & Shop supermarket is now located. Perhaps the greatest change is the relatively new housing at Hilltop to the left of Main Street. The Route 8 expressway would be just beyond the right side of the picture. Mindful of its incredible past in the last century and a half, the City of Ansonia looks forward to many more years of progress as it enters the new millennium.